ENCHANTING BIRDS

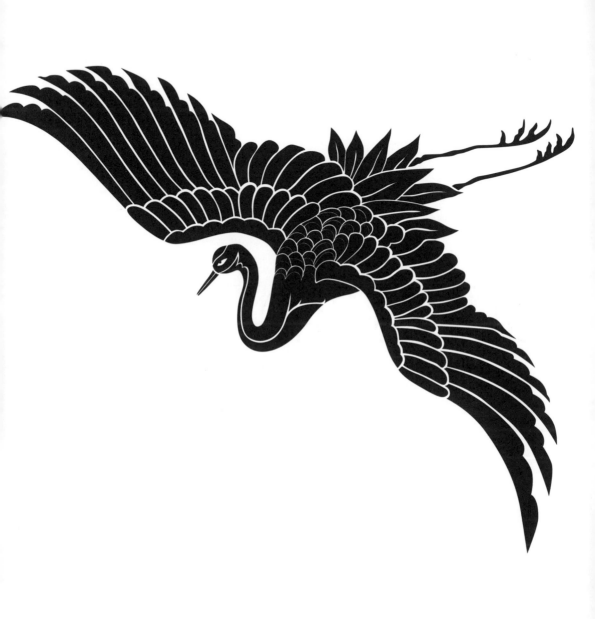

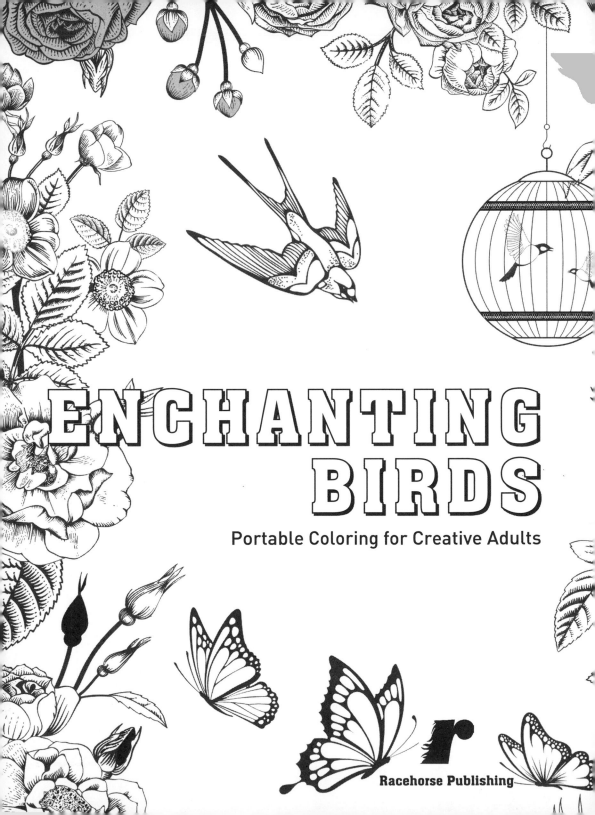

ENCHANTING BIRDS

Portable Coloring for Creative Adults

Racehorse Publishing

Introduction

Let your imagination soar! And now you can do it anywhere you choose!

Coloring has always been a great way to let your creativity loose, whether coloring on your own or in coloring books. You have taken the first step and bought this fantastic book! Thank you. But that was the easy—and boring—part. Now the real fun begins.

Regardless of whether you haven't colored since your youth or often find yourself with a colored pencil in your hand, don't think too much, just get going without reservations. Enjoy the beautiful pictures and designs collected within and allow your mind to wander. You can begin to add your colors anywhere you please or you can work methodically. It is up to you!

There is no need to color within the lines if you don't want to. Turn the world inside out and let positive and negative, light and dark, trade places. You can also concentrate on coloring outside of the image, paint with one color at a time, or use multiple colors at once and create effects with lines, dots, and other patterns. Or why not put colors on top of each other or vary lines in different colors?

Be free in your creativity! Let the moment that you devote to coloring create calmness, and experience how relaxing and peaceful it is. This kind of picture therapy can help you deal with stress and become more present in the moment. Even professional artists can experience a great deal of dread facing a blank sketchpad. You need not worry when you open your portable coloring book because it is filled with wonderful designs that will inspire, not intimidate, you.

Don't forget, your coloring book is yours and only yours, and you're allowed to engage in a process of trial and error. You can begin and end your coloring whenever you want! You can sketch freely or get absorbed by your coloring whenever you're in the mood. You can be as careful or sloppy as you please.

Enjoy!

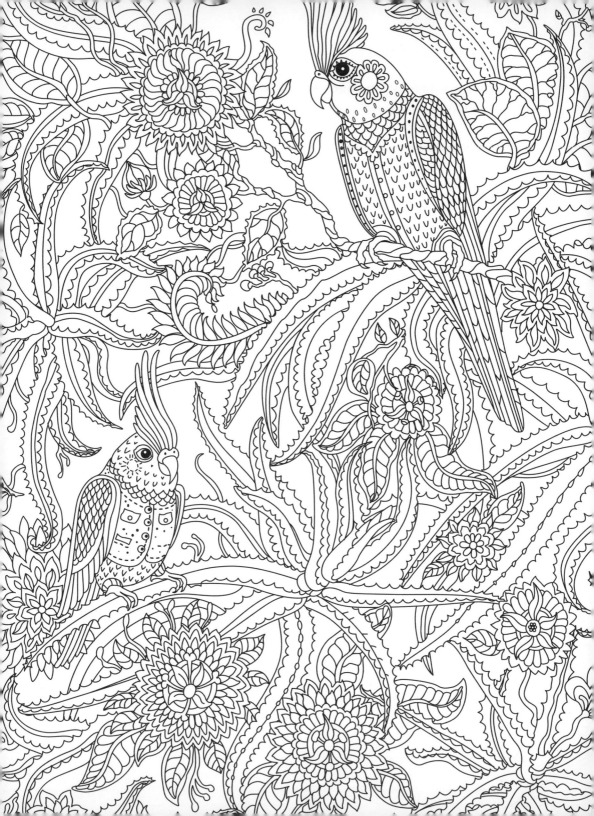

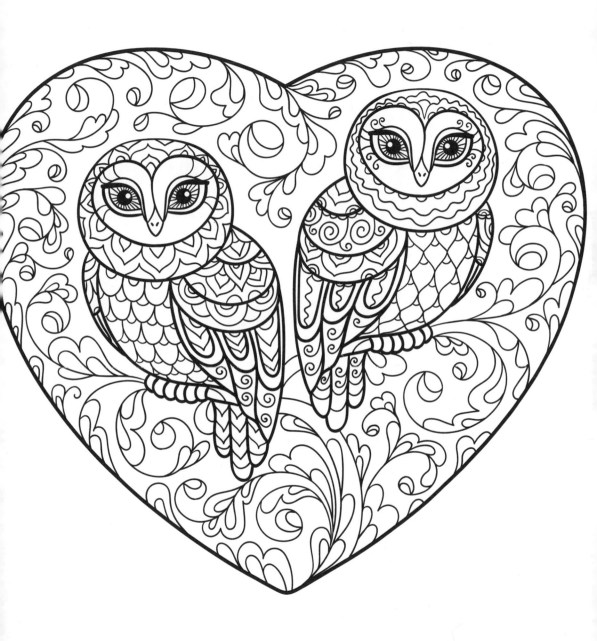

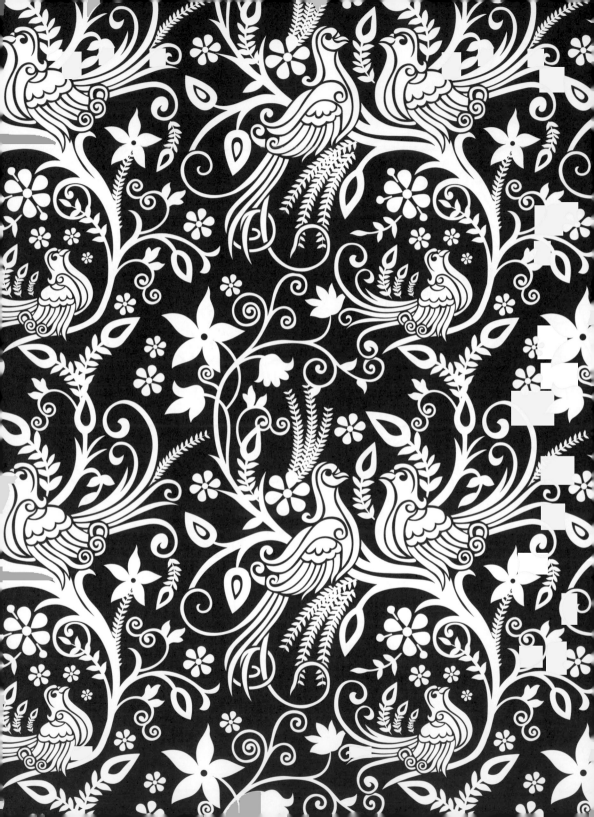

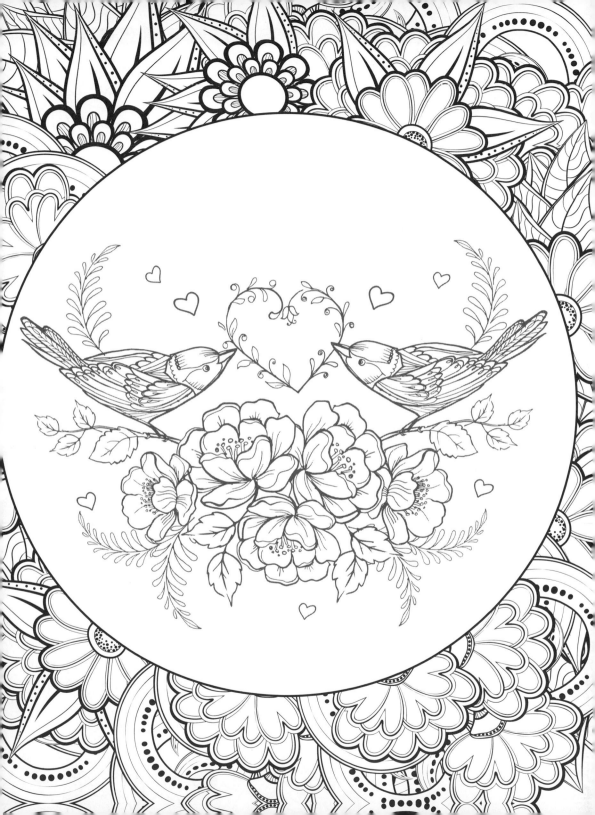

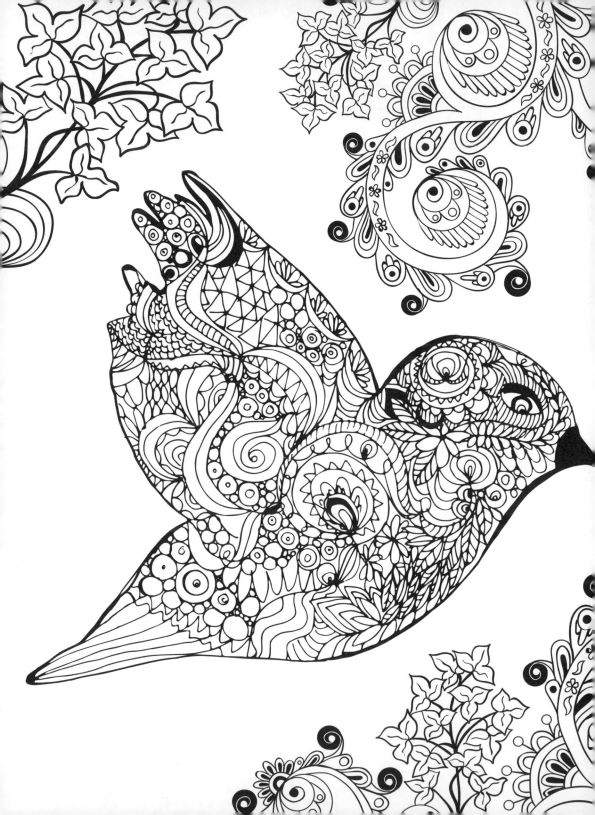

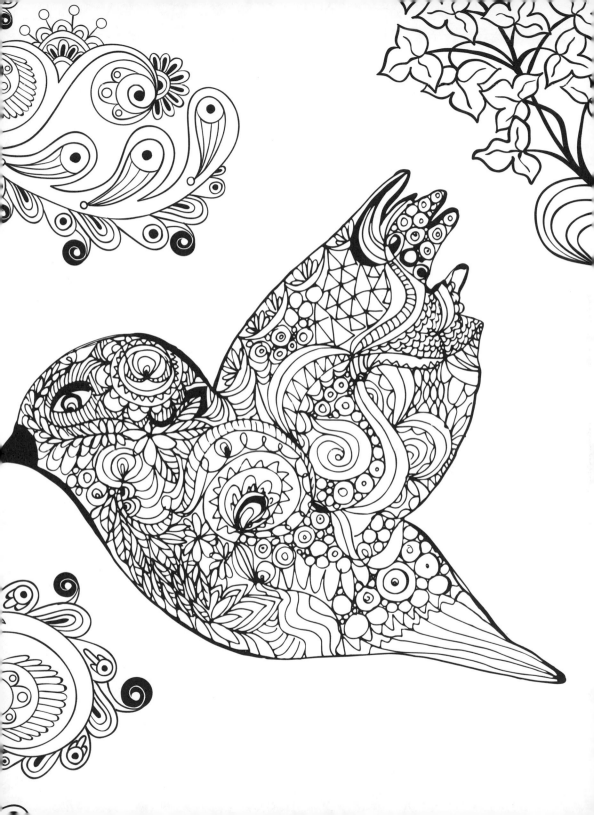

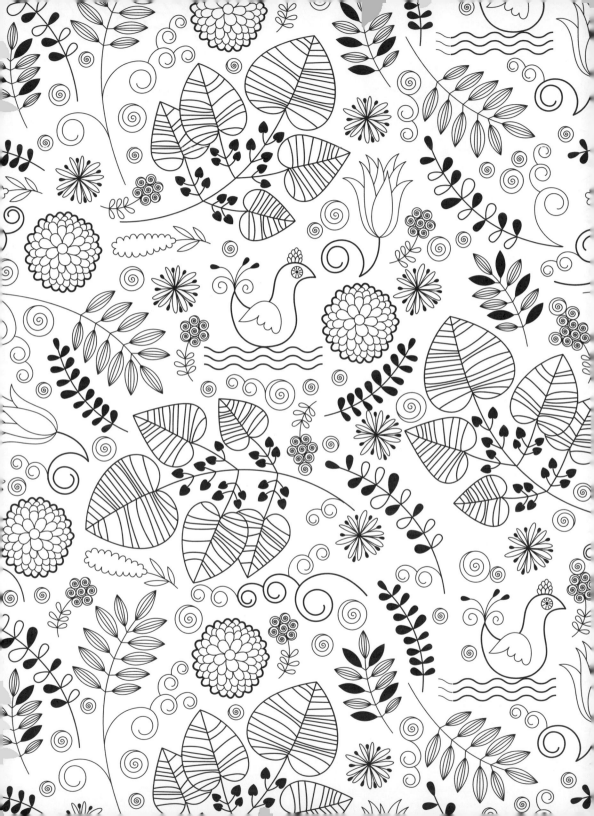

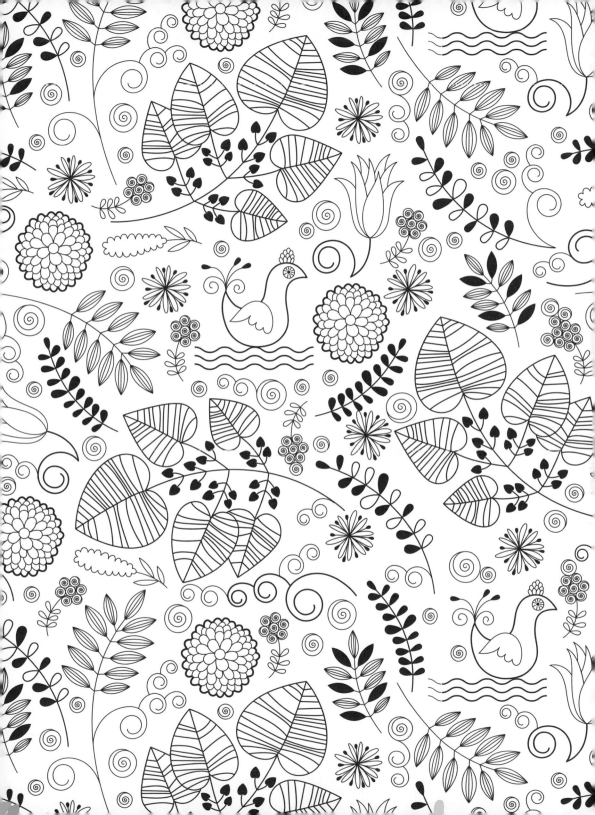

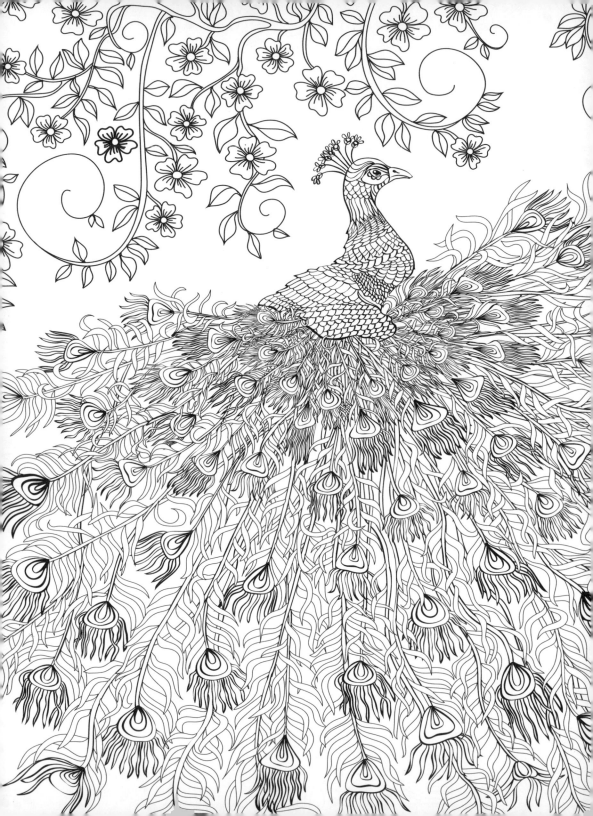

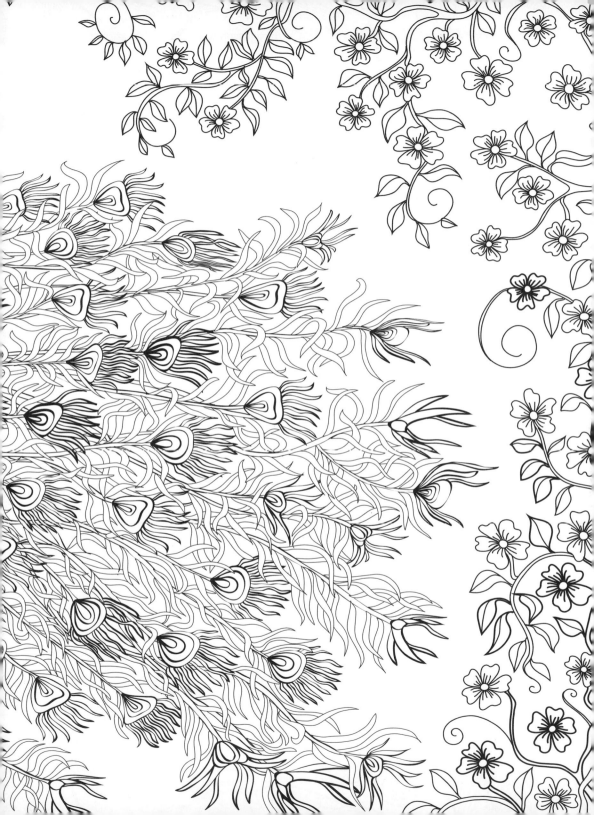

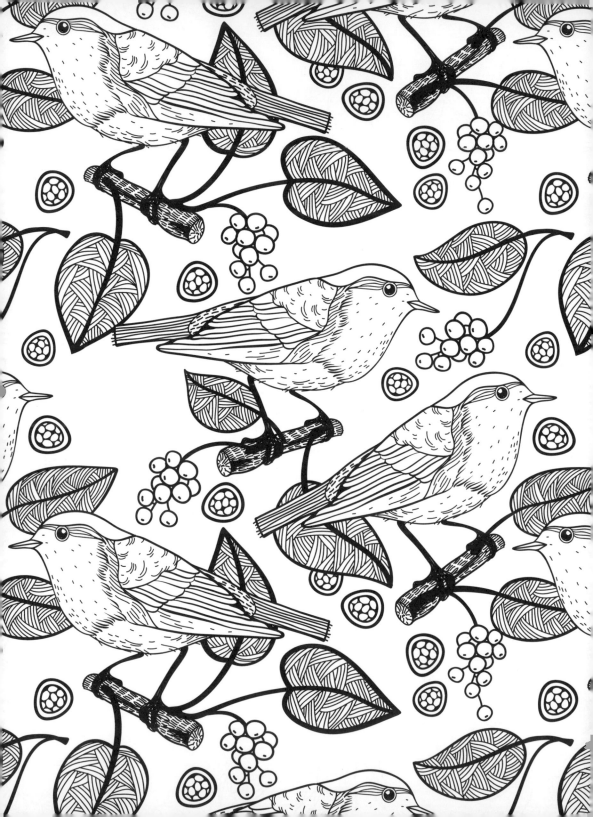

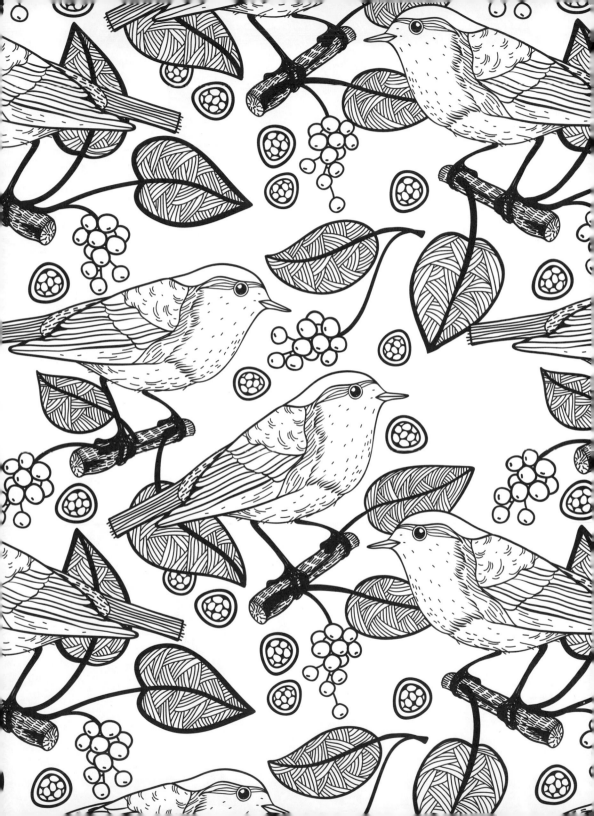

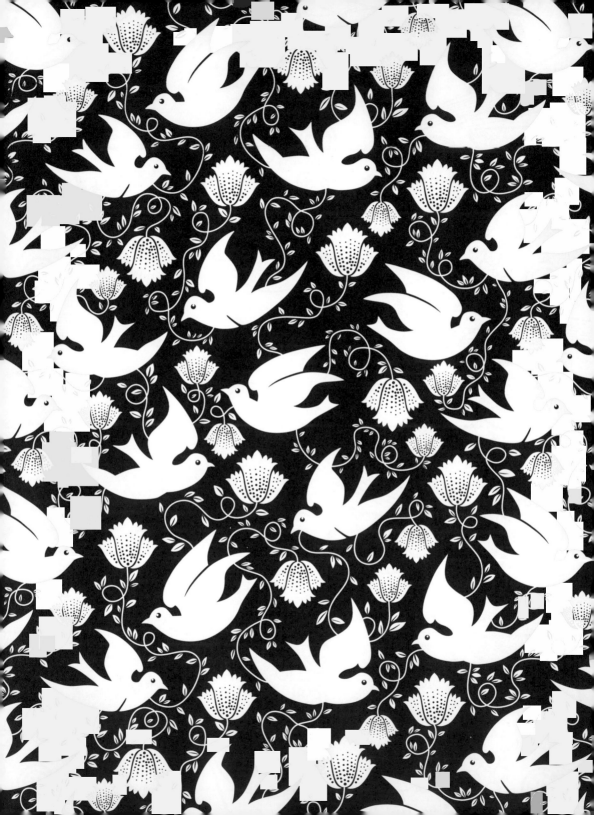

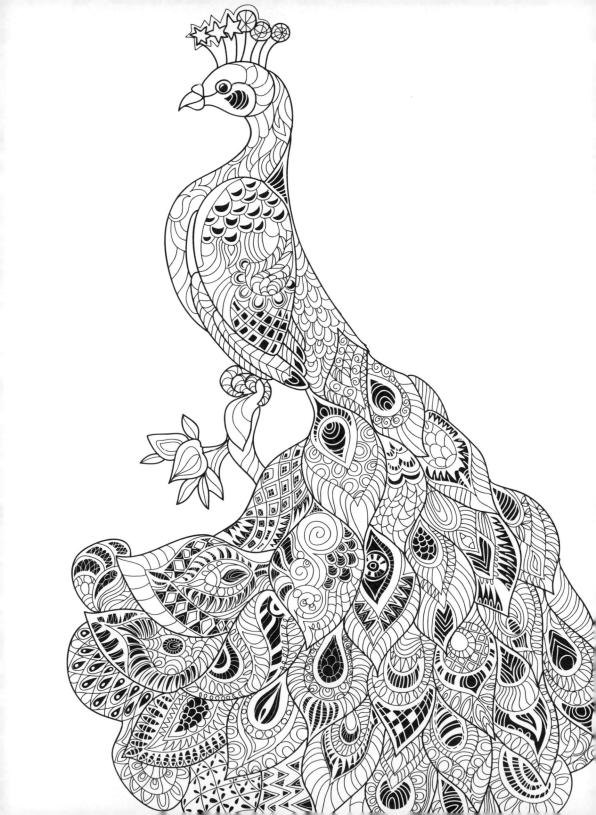

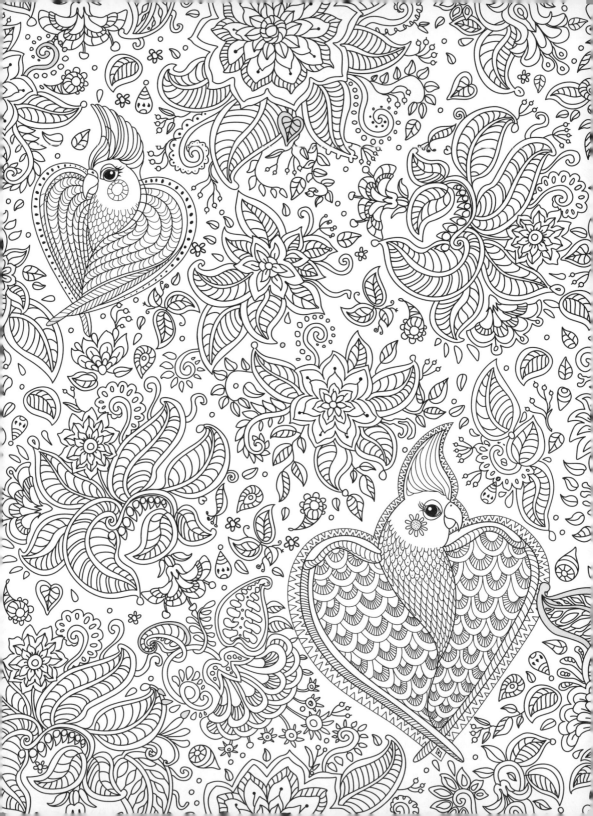

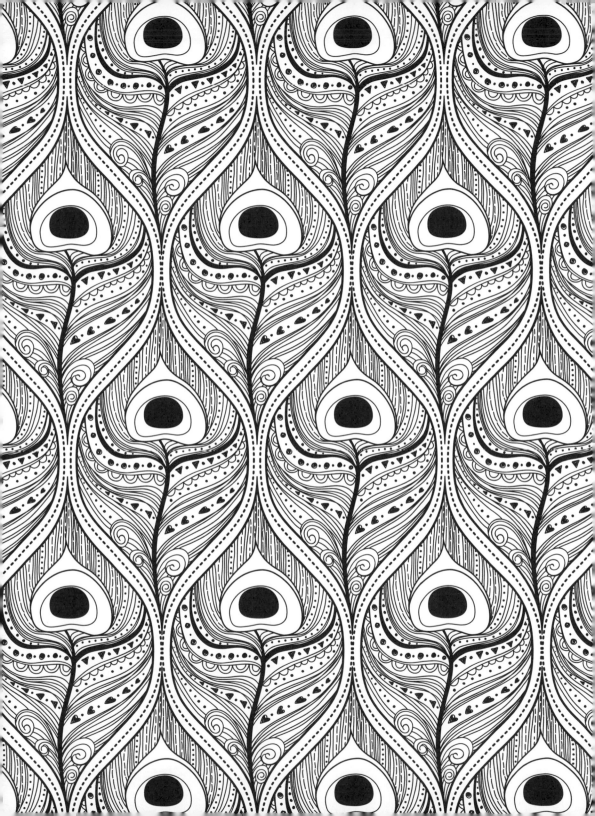

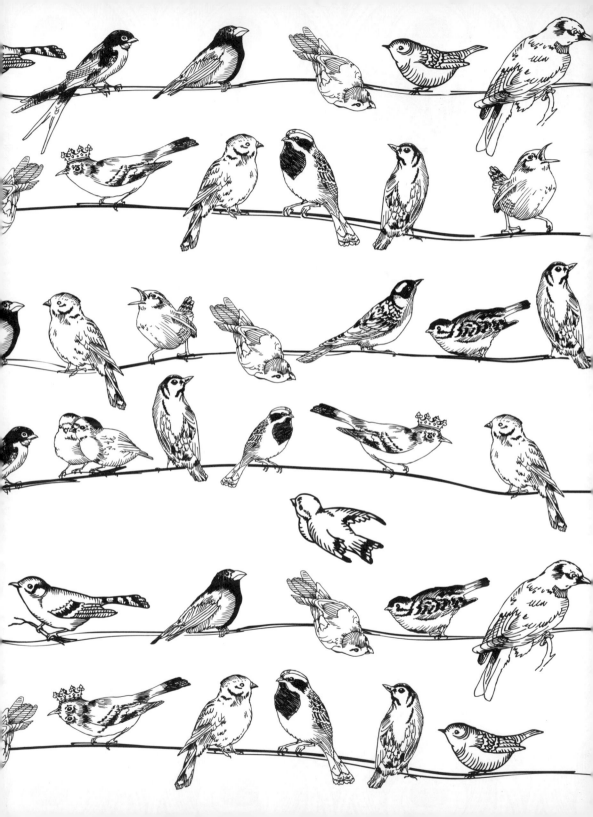

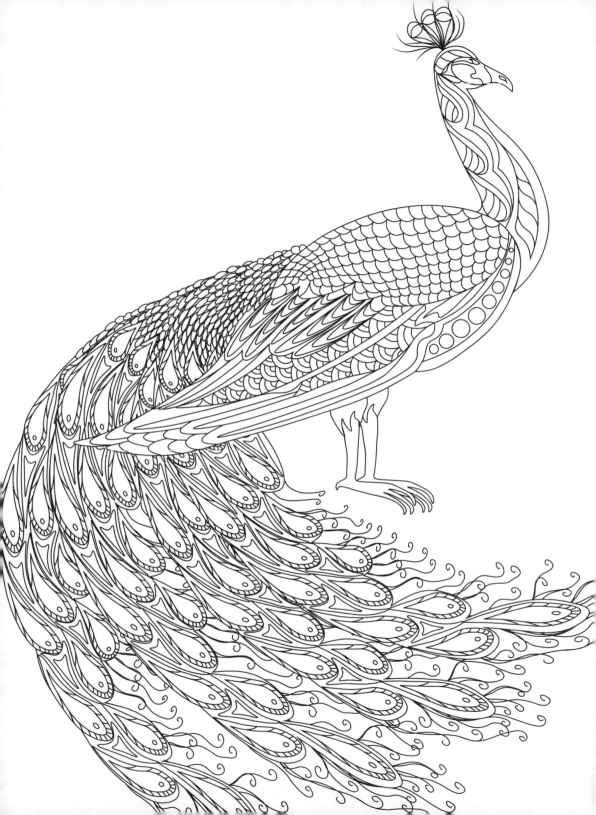

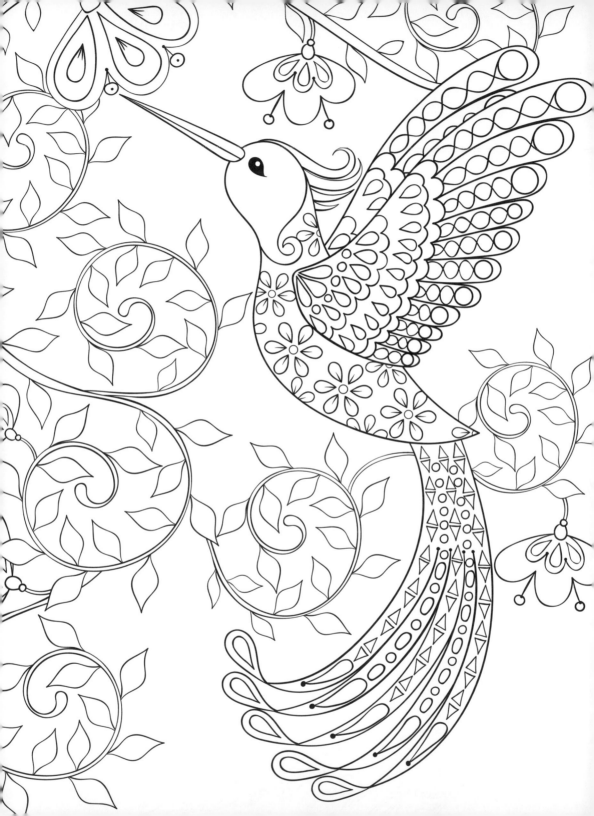

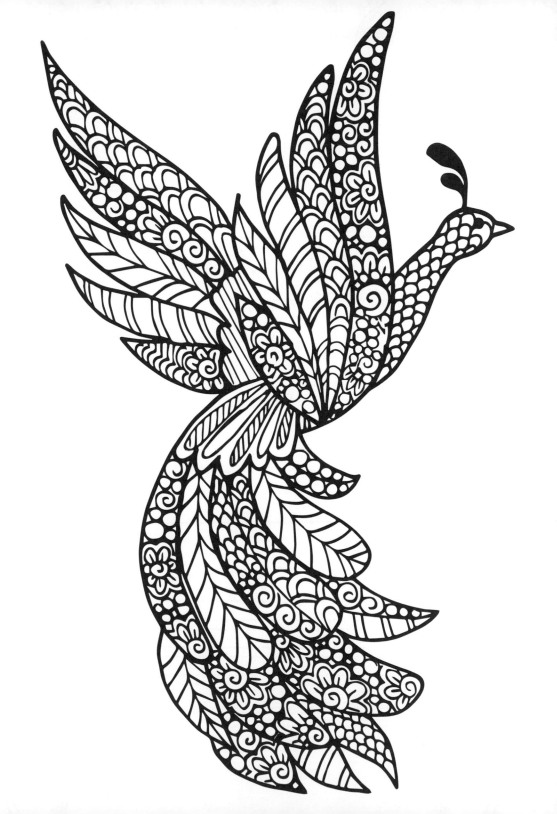

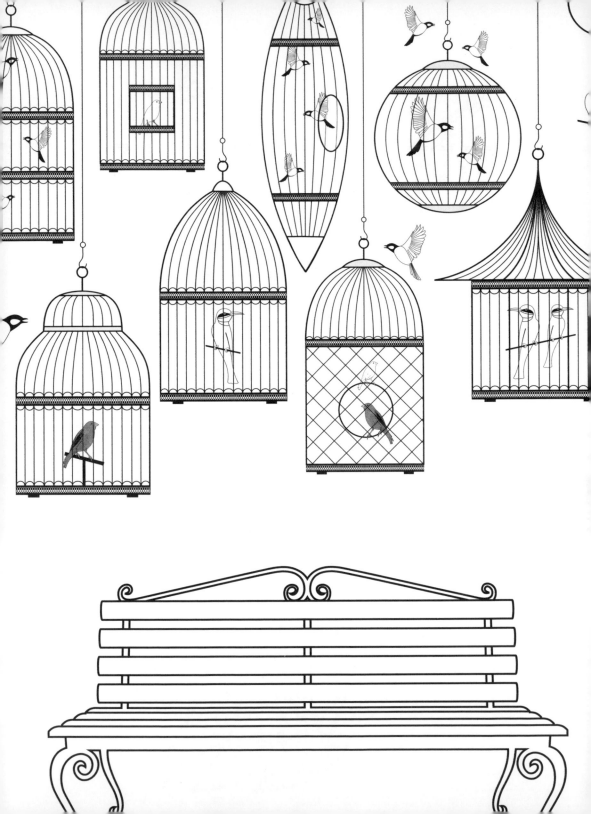

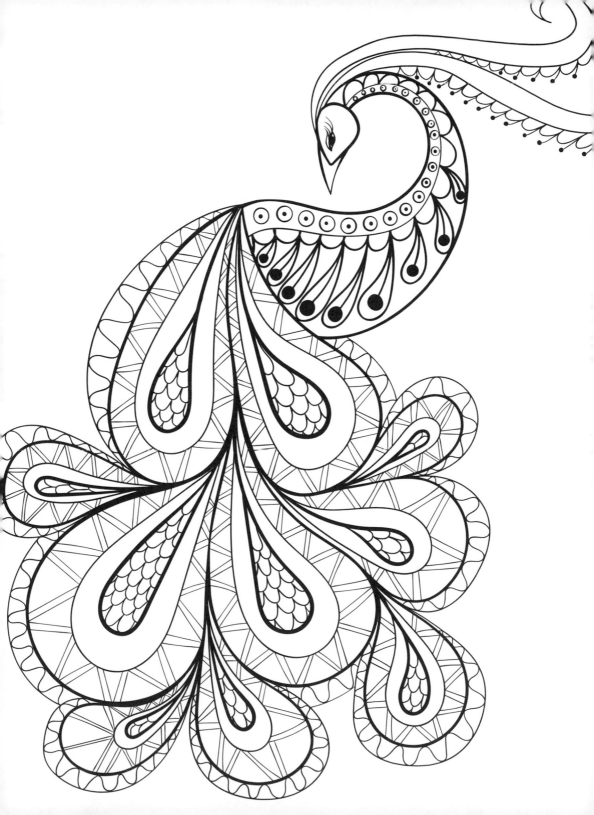

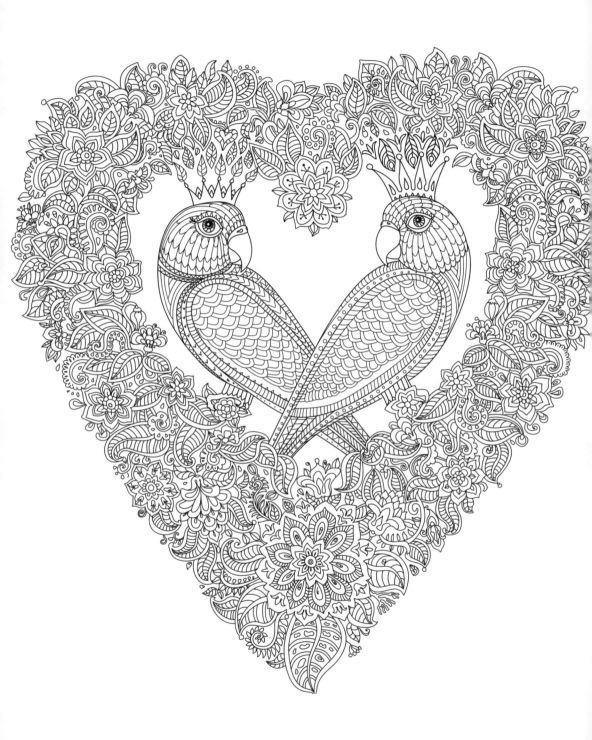

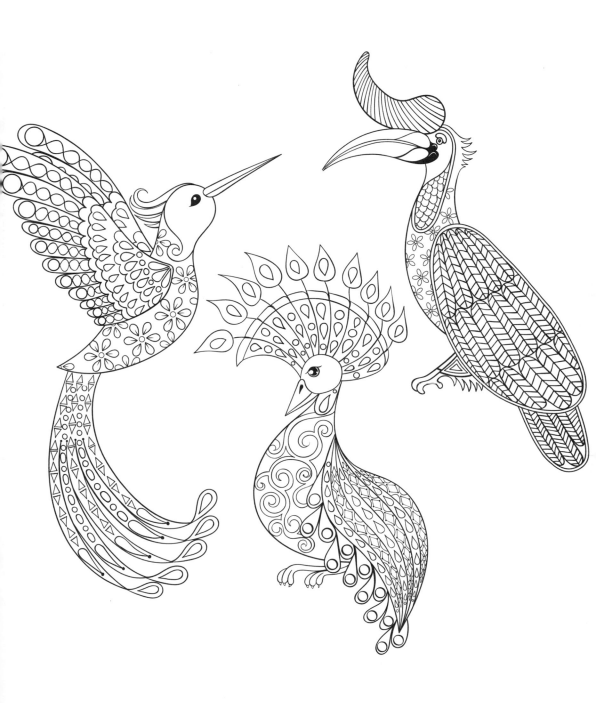

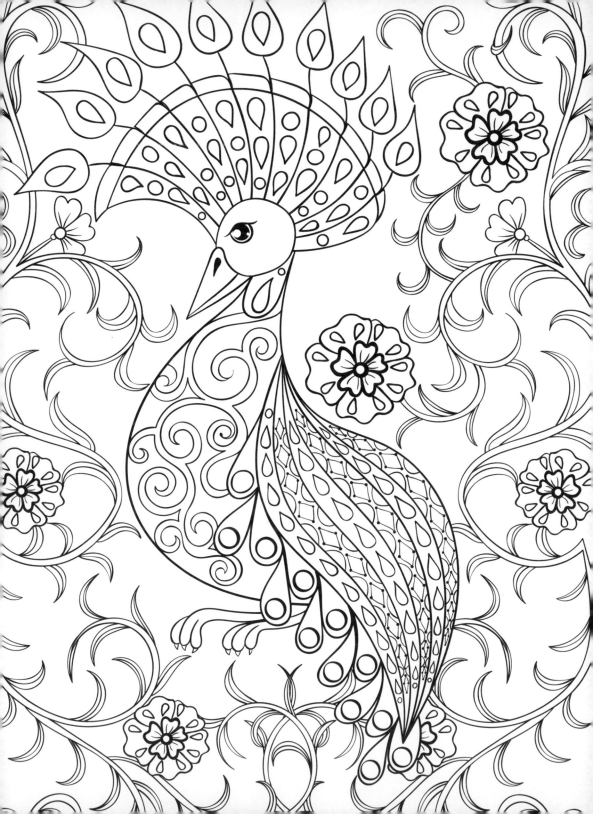

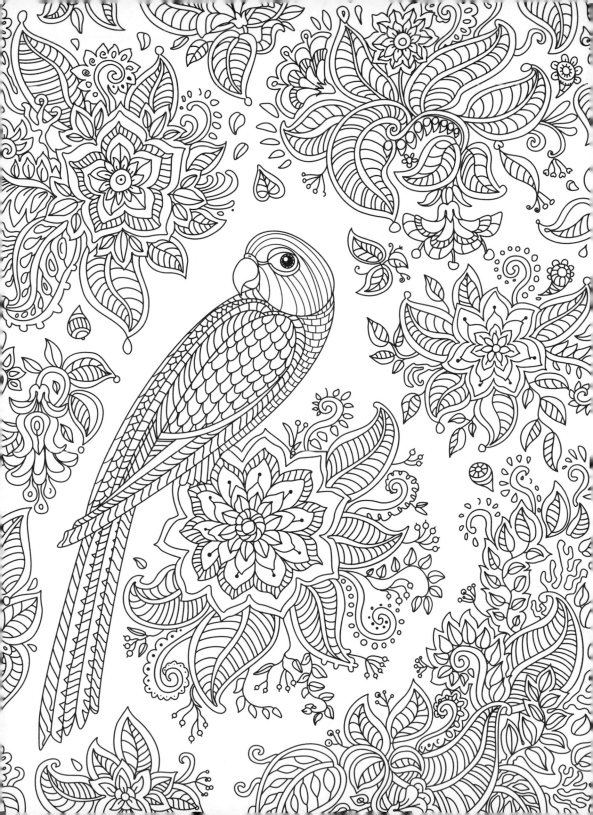

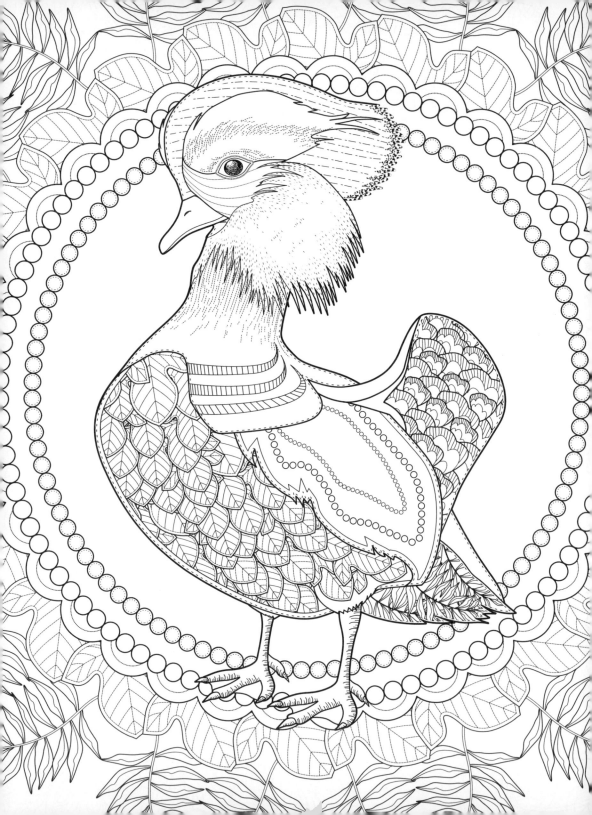

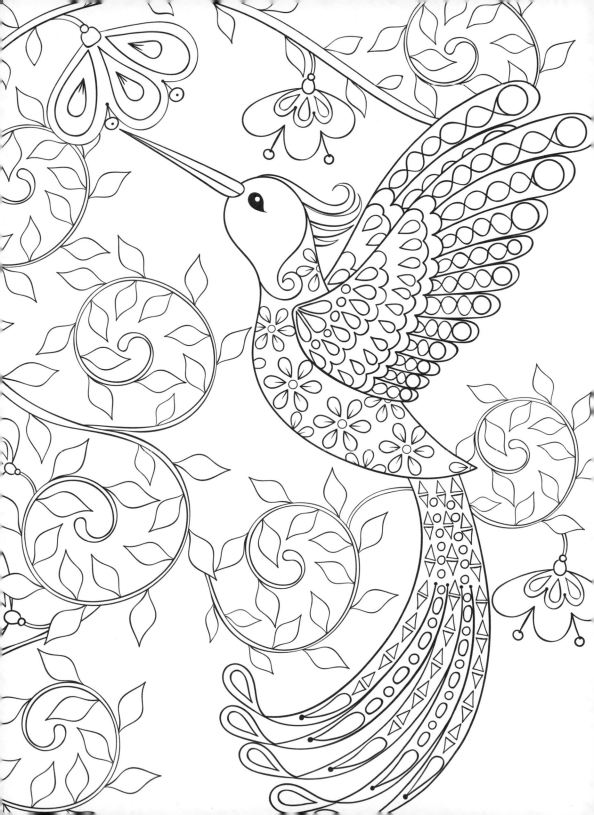

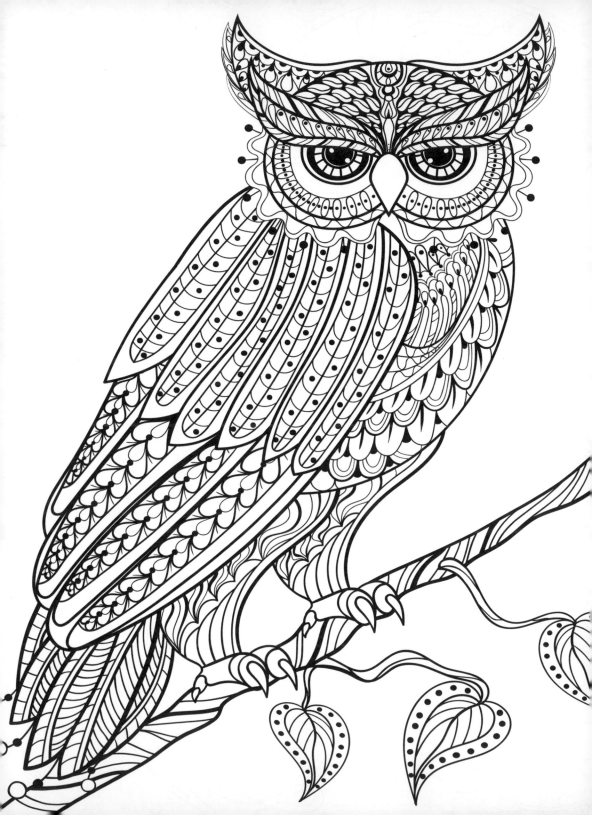

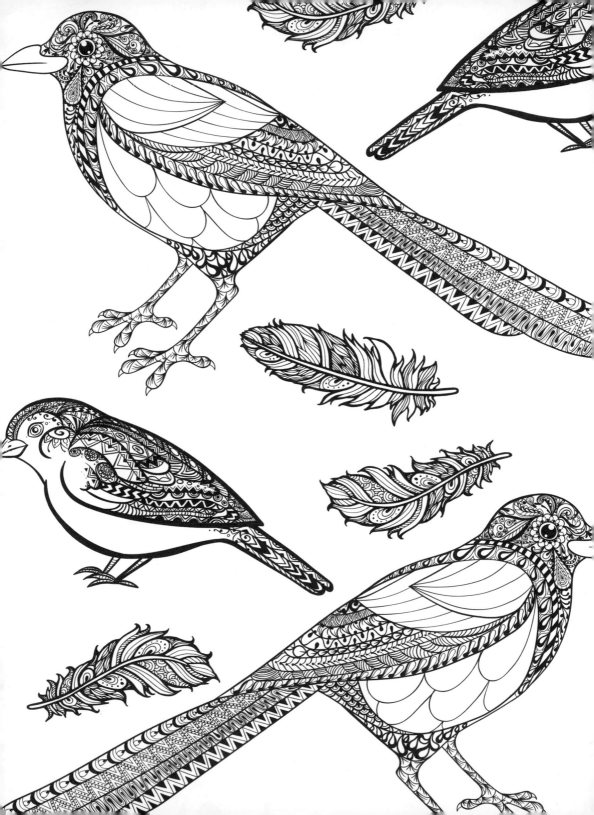

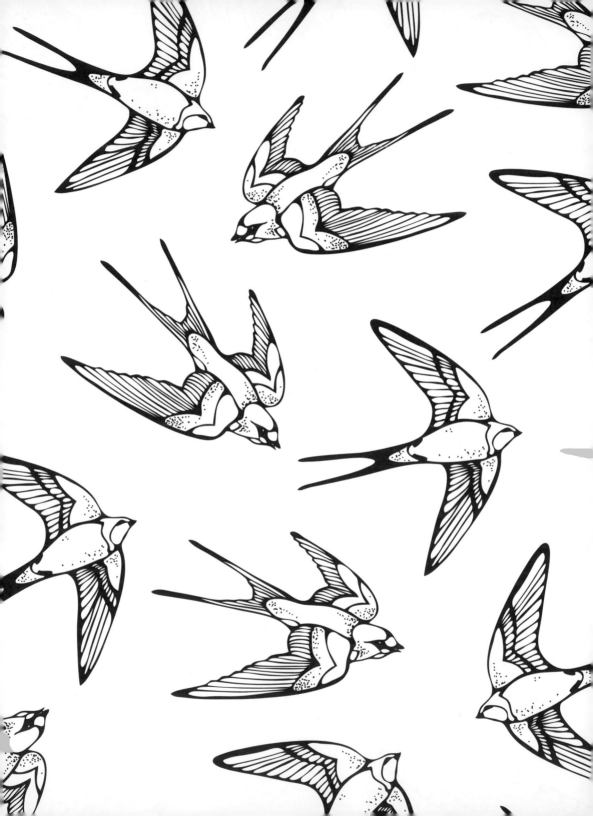

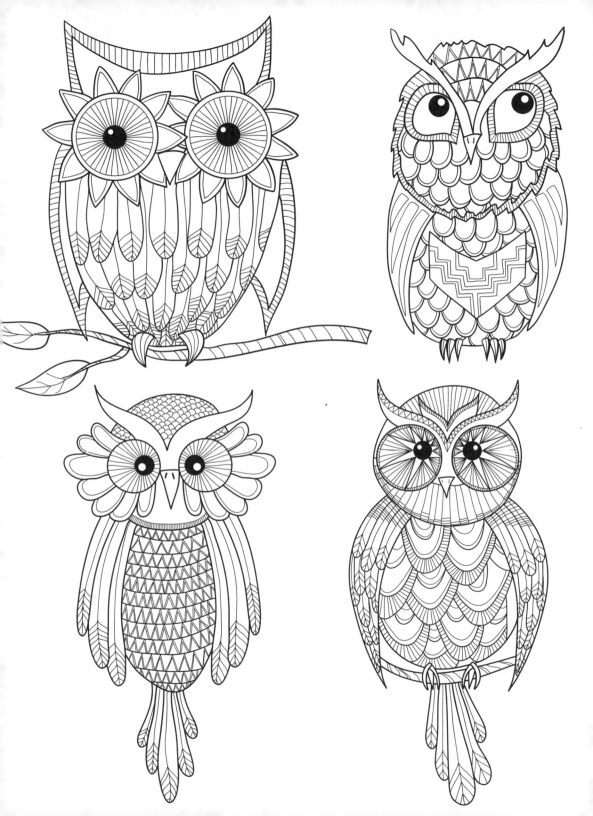

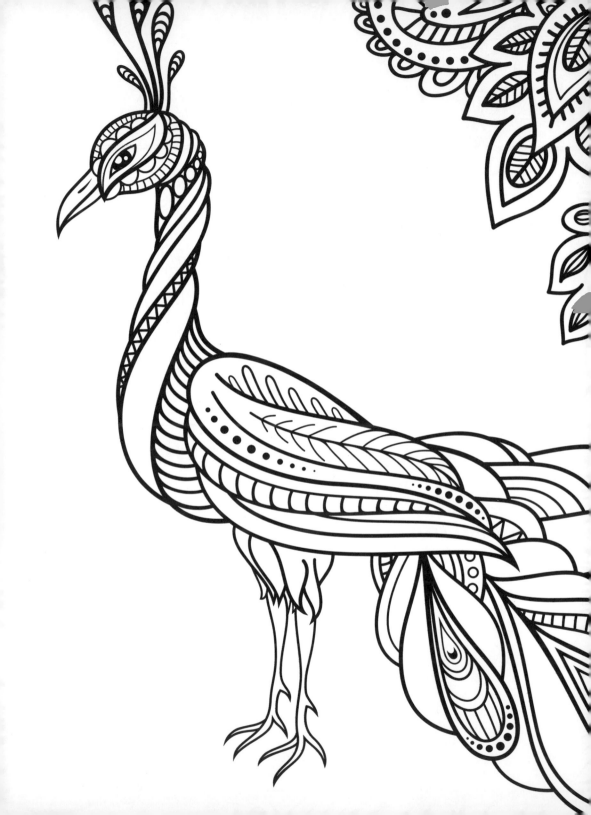

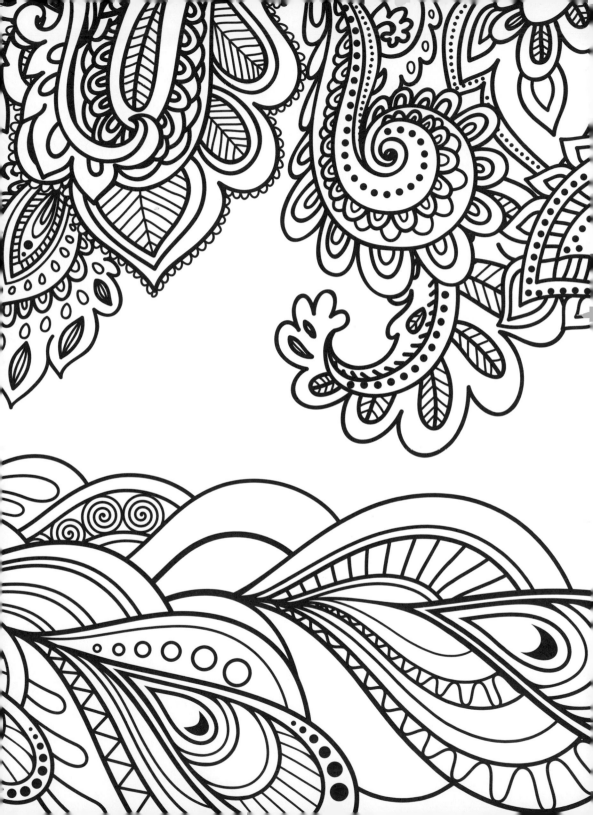

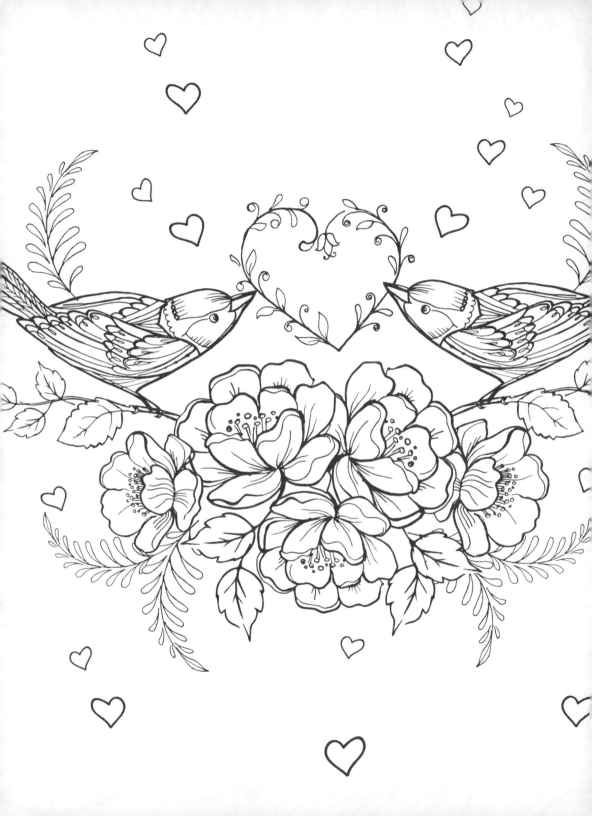

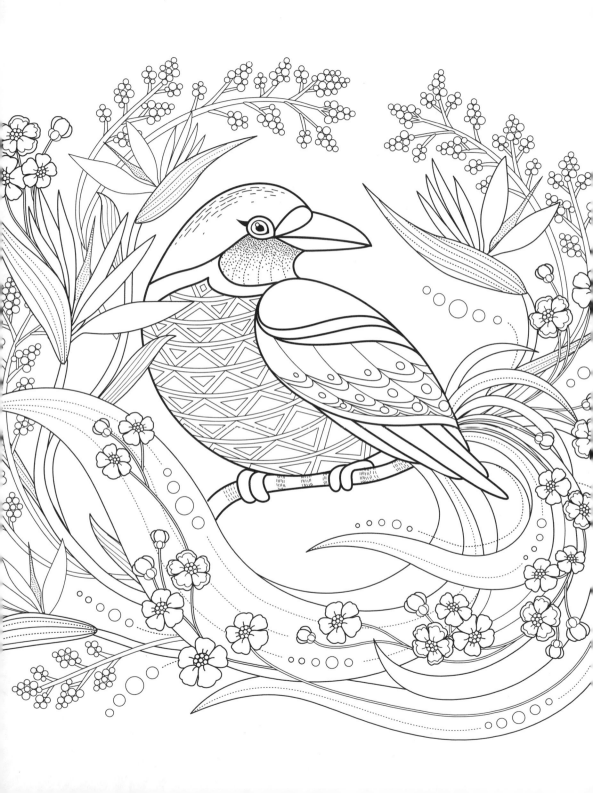

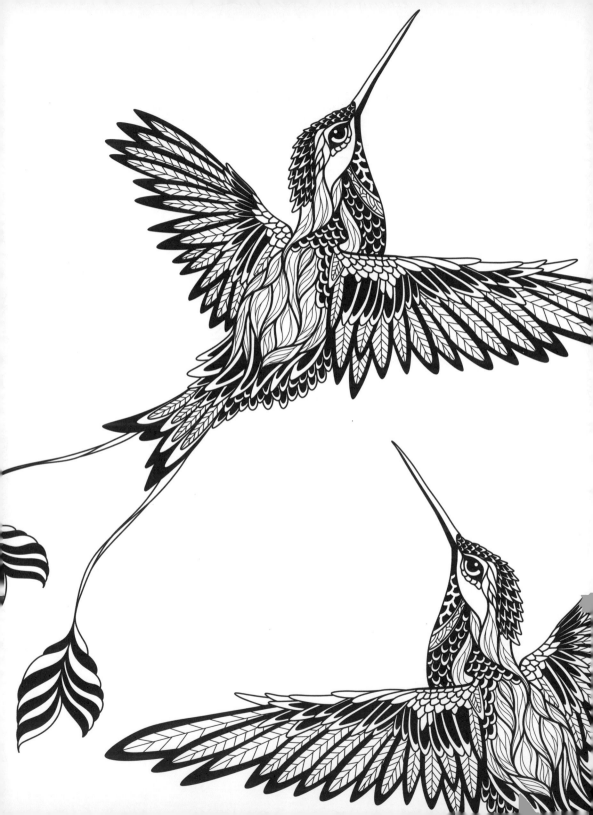

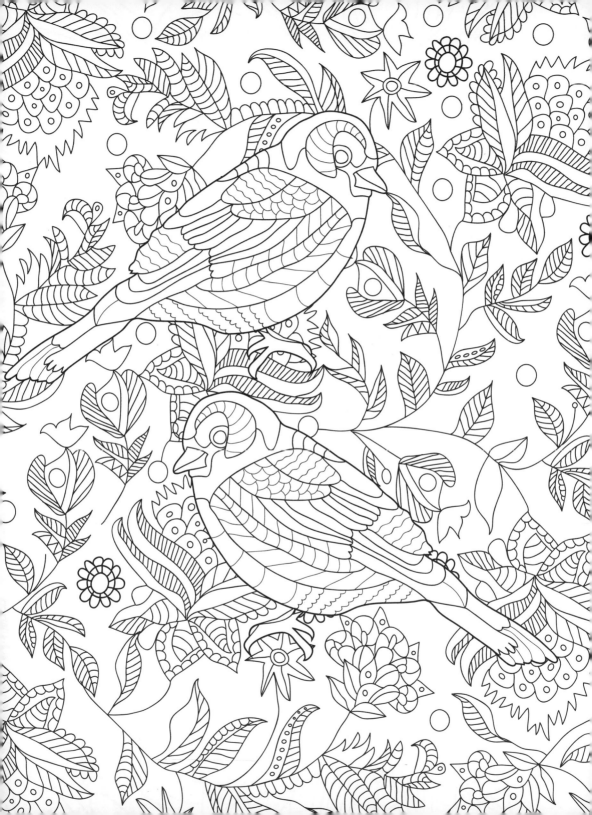

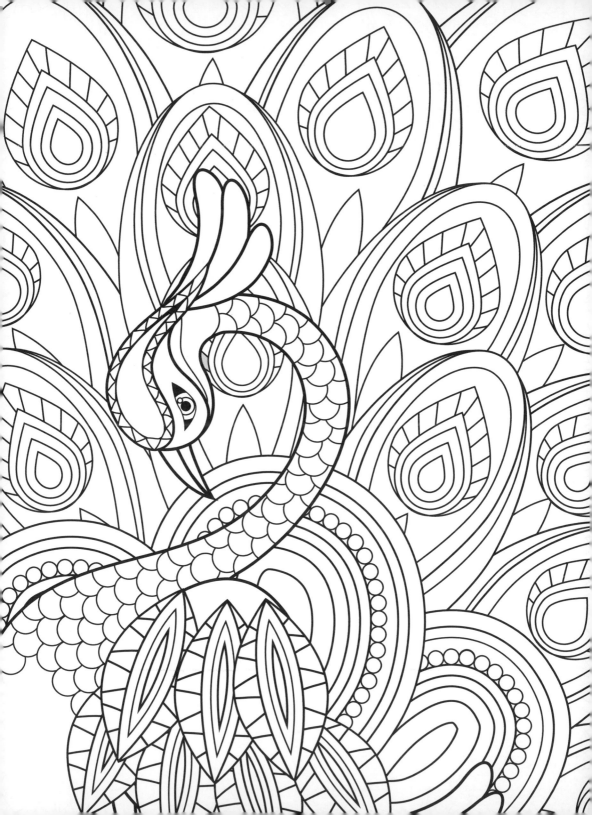

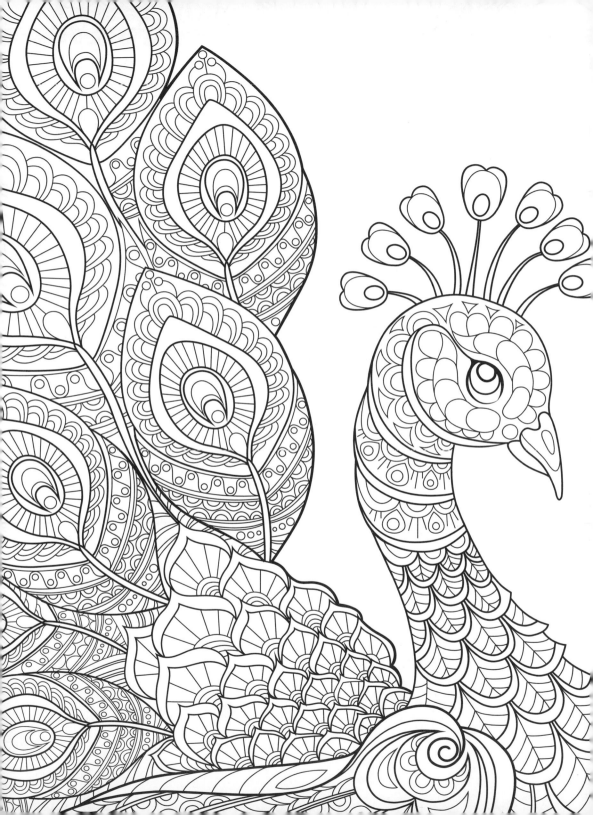

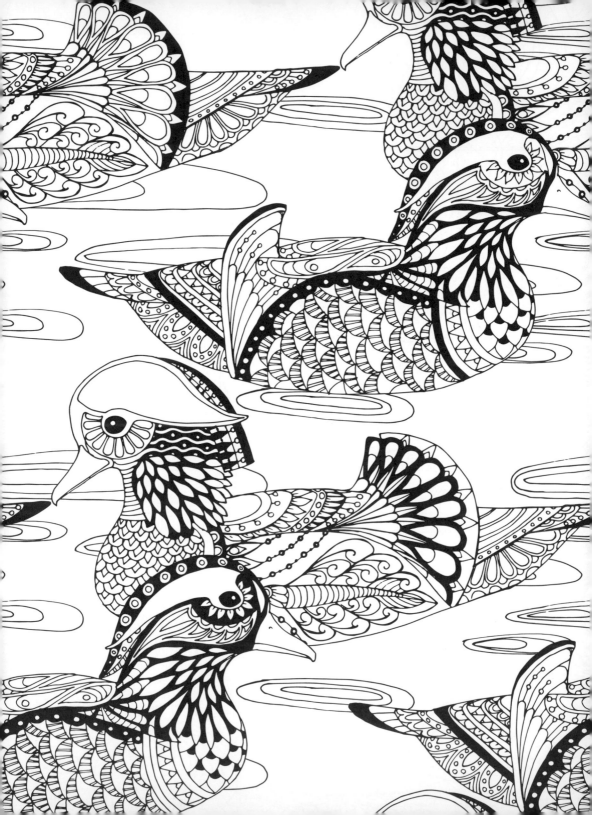

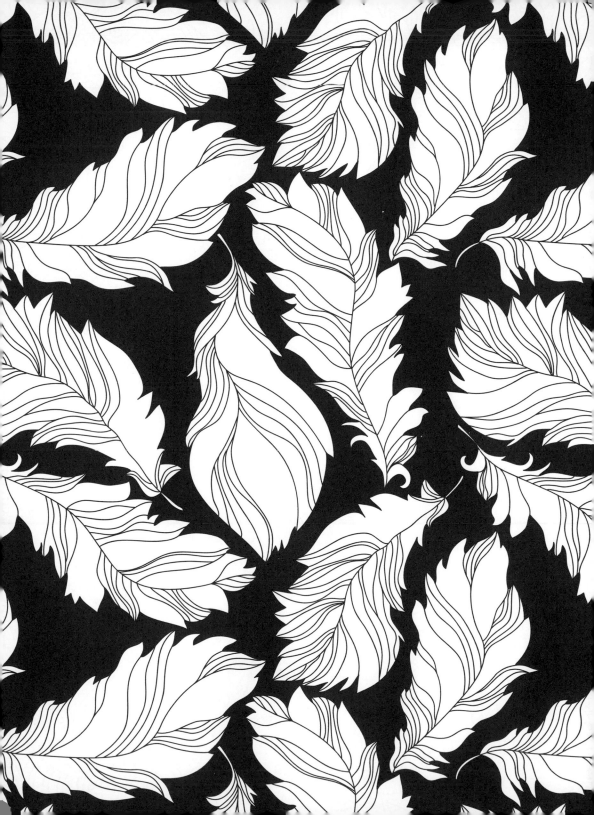

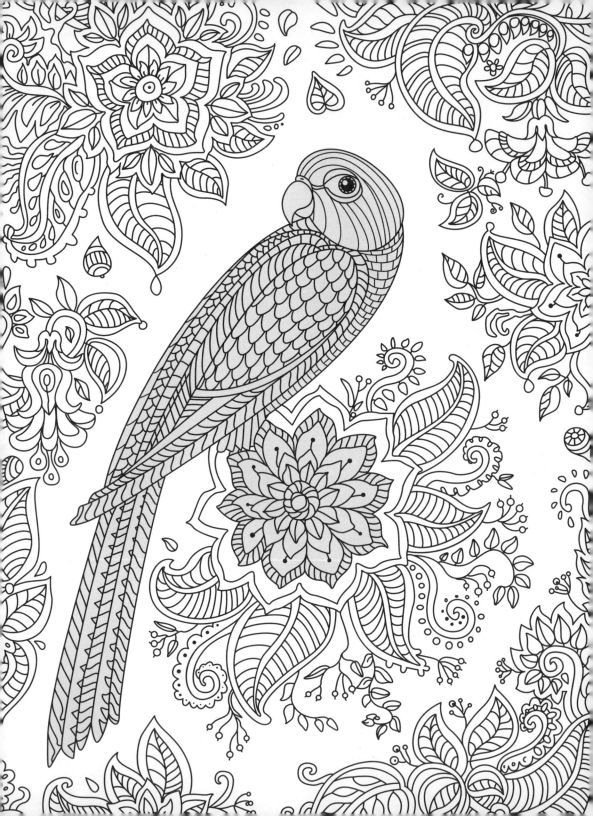

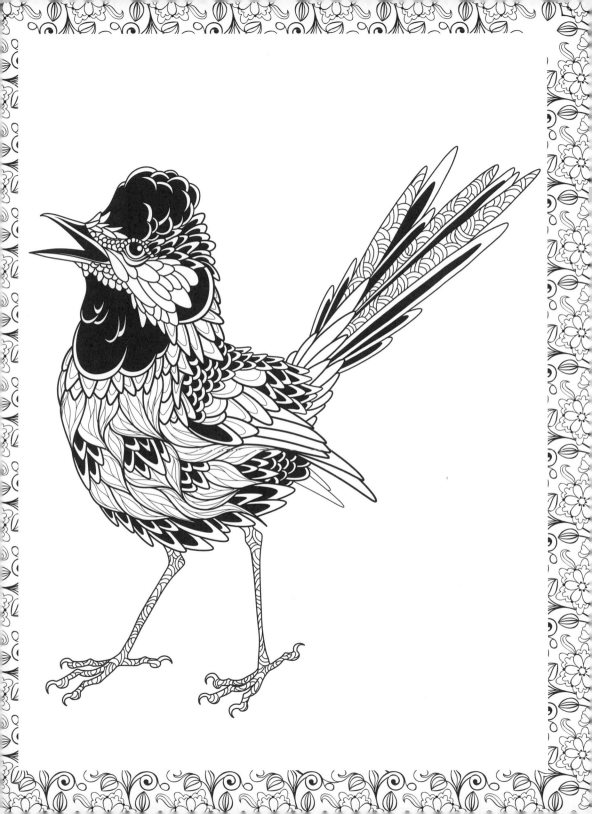

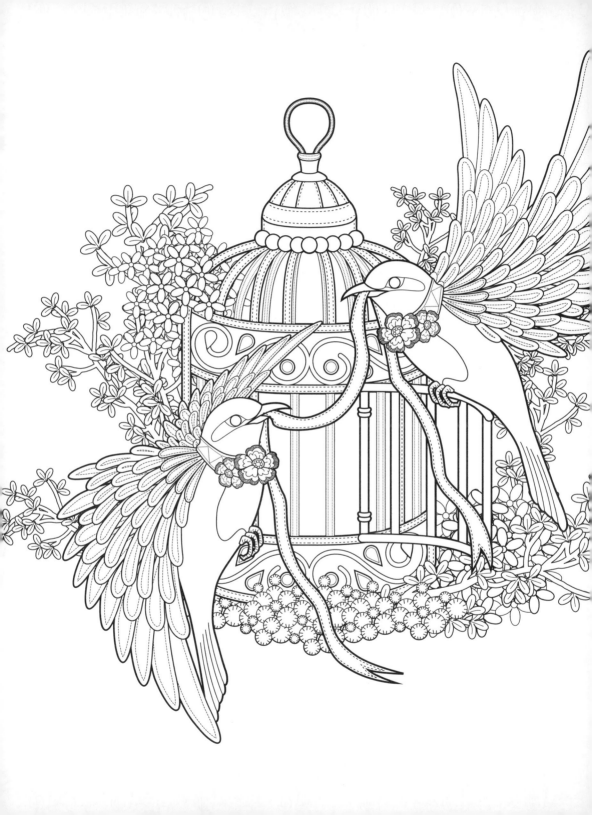

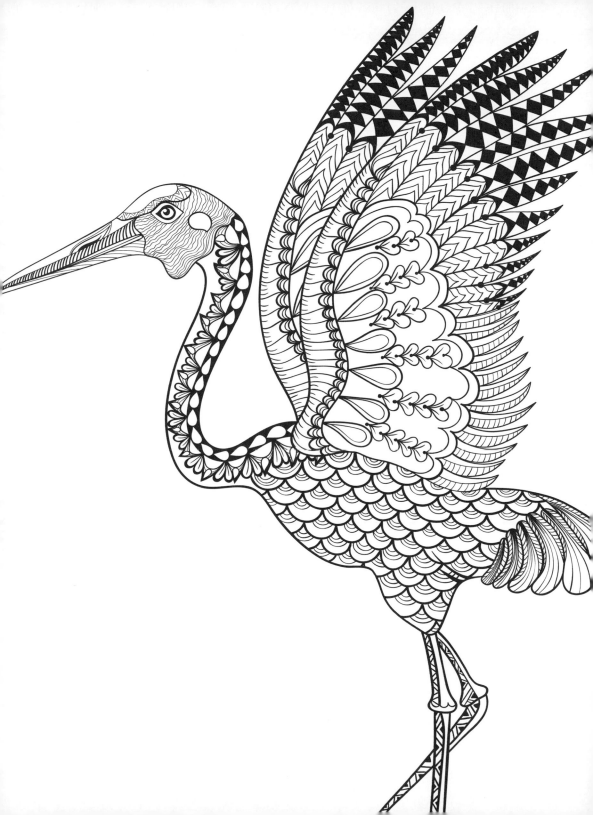

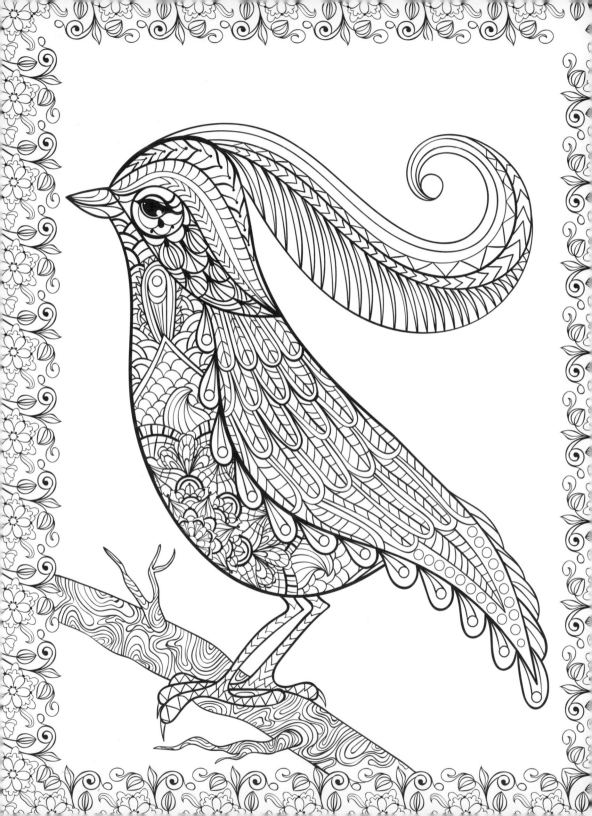

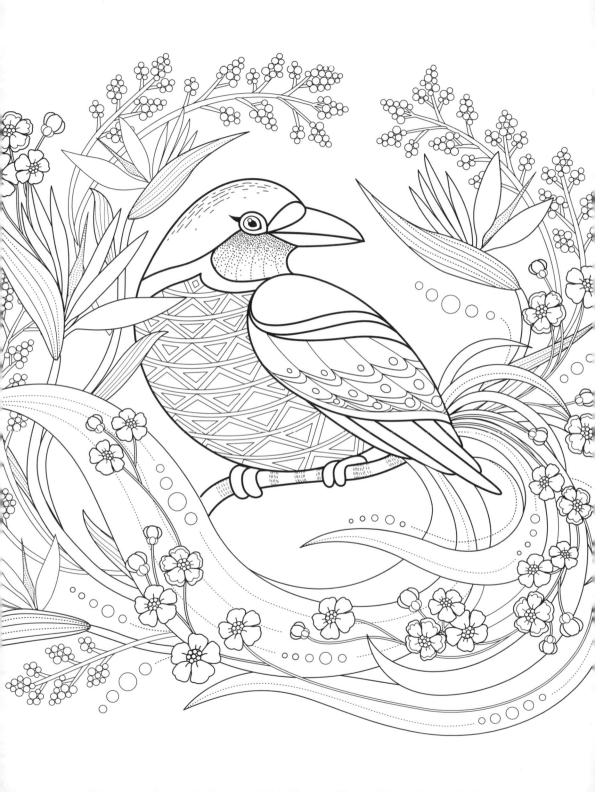

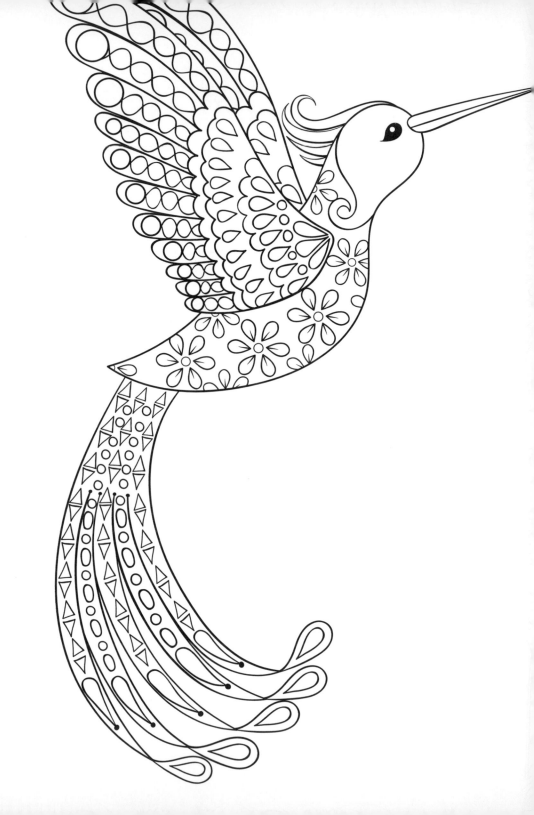

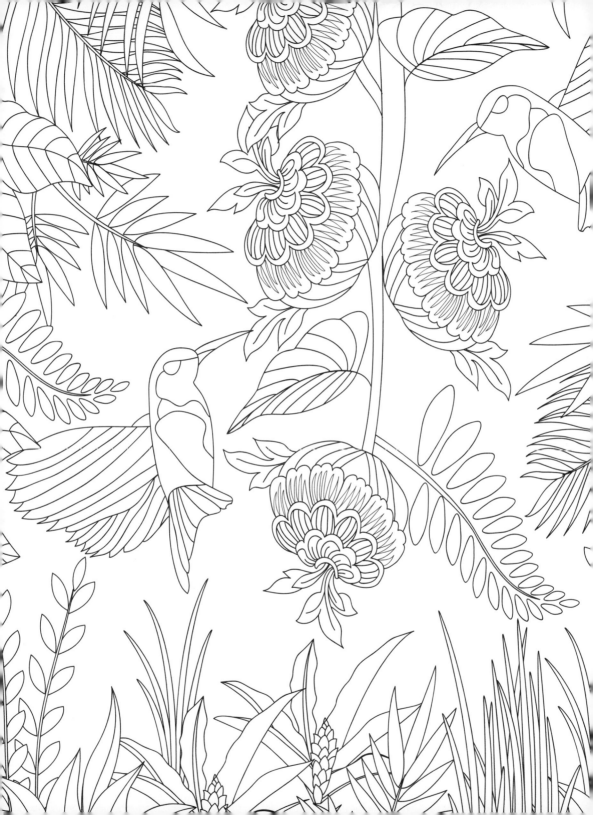

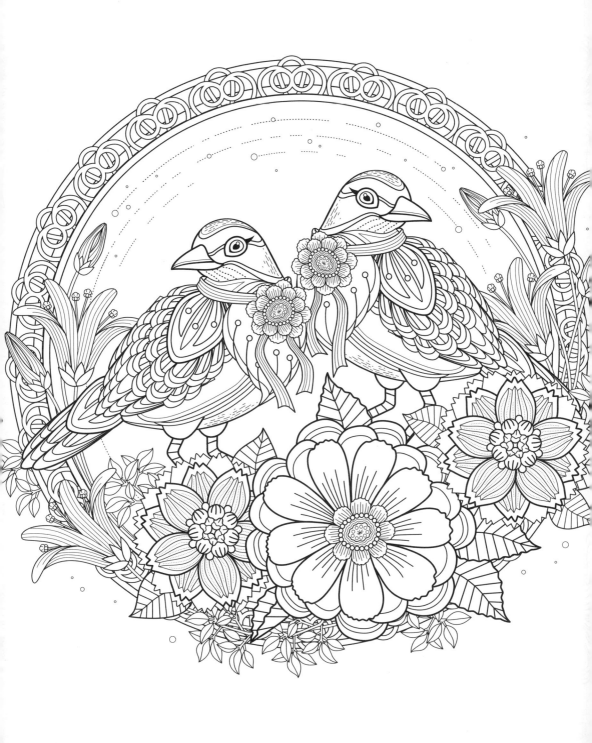

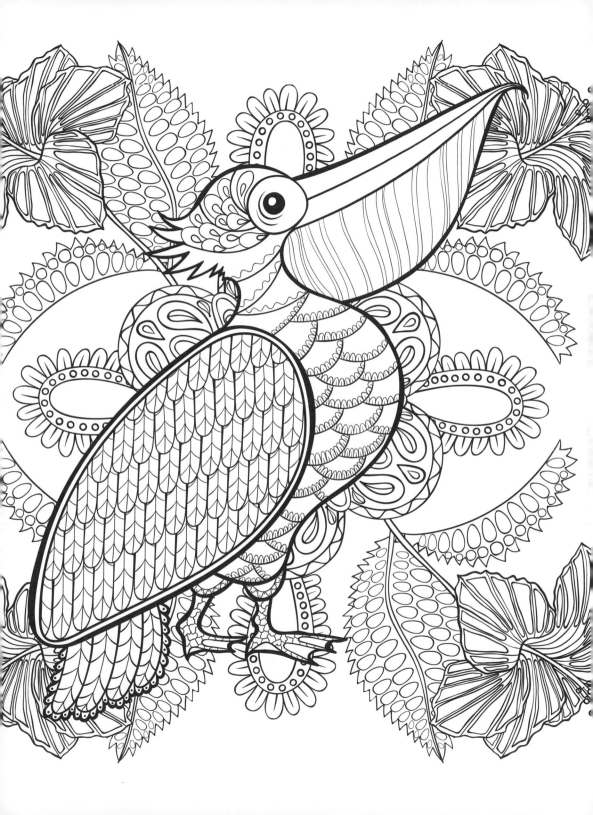

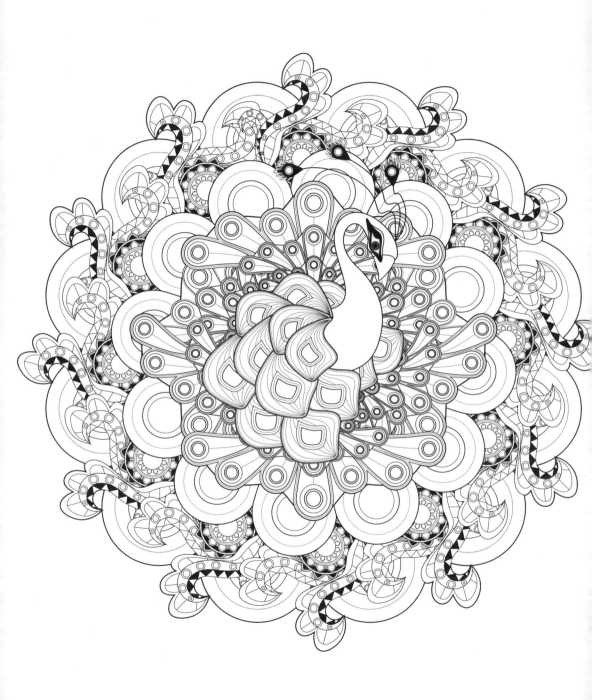

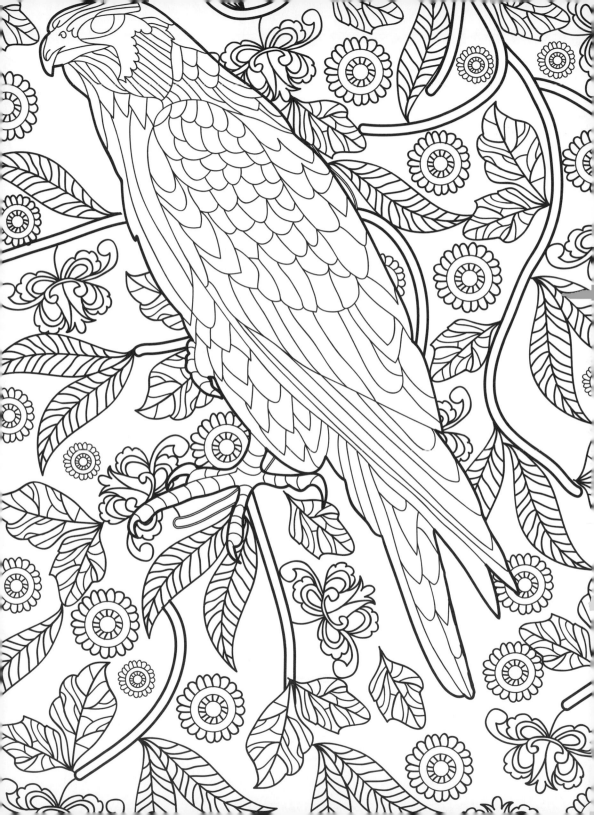

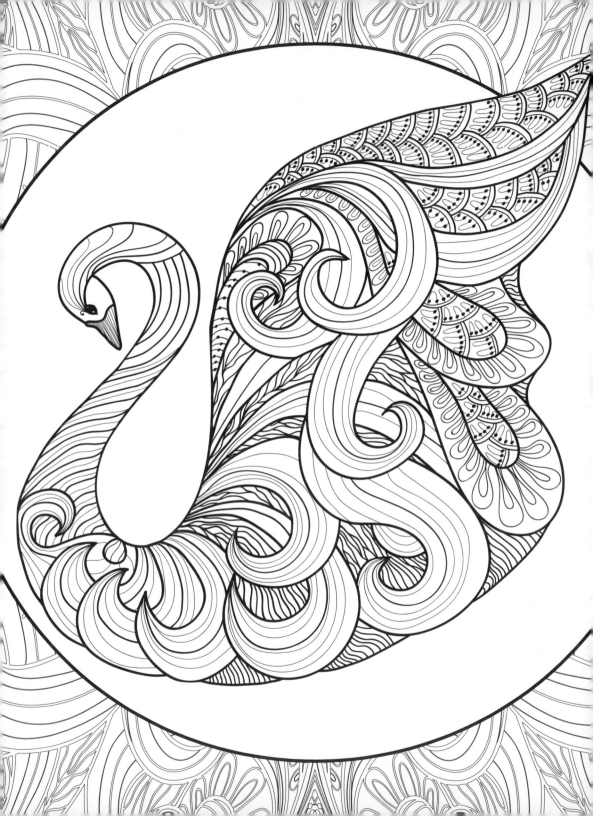

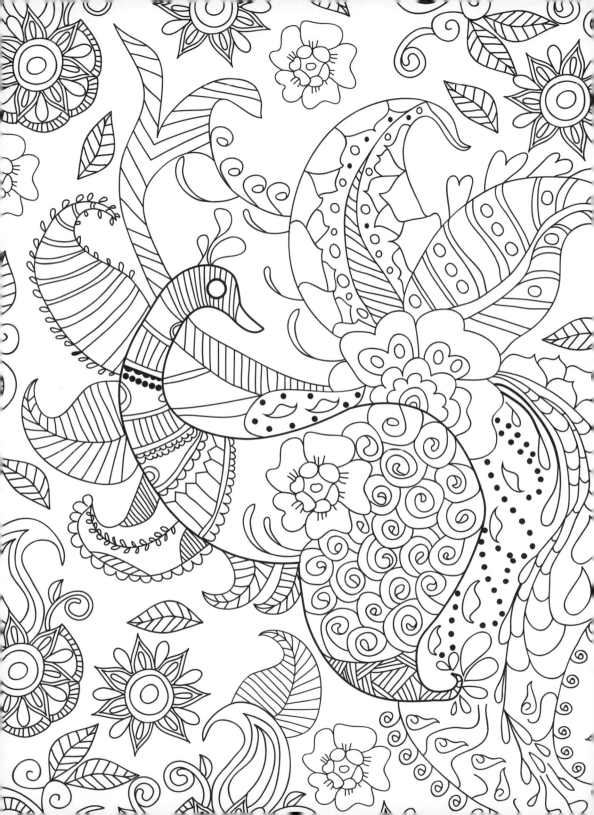

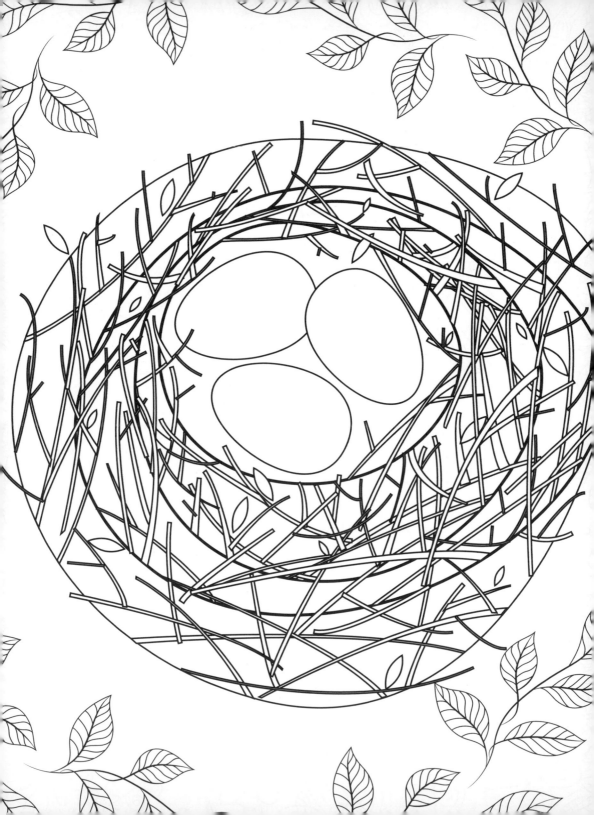

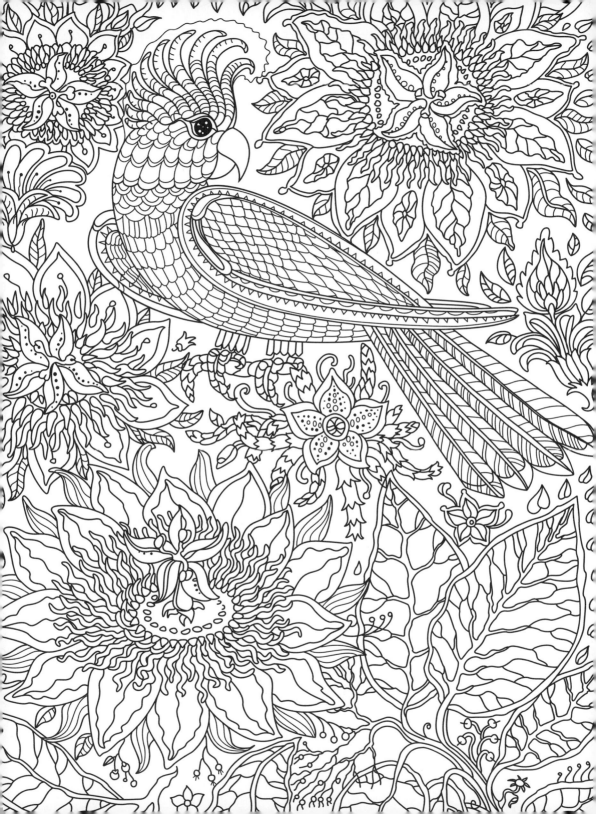

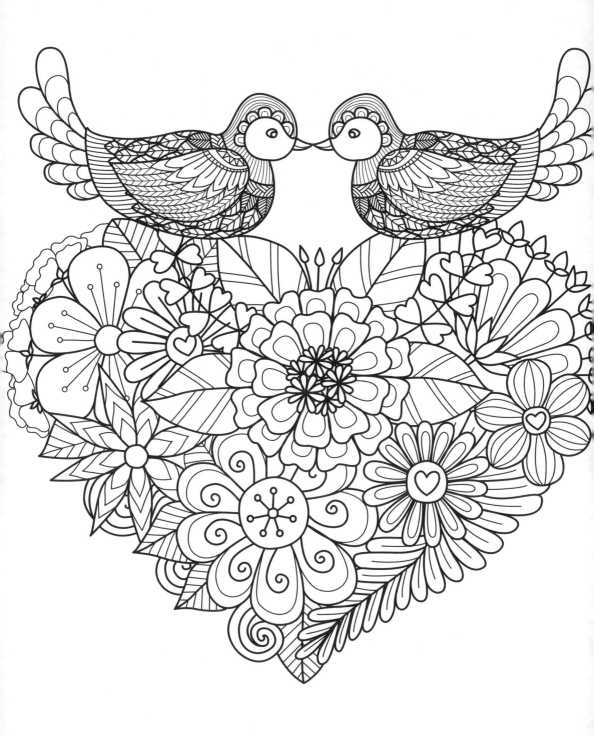

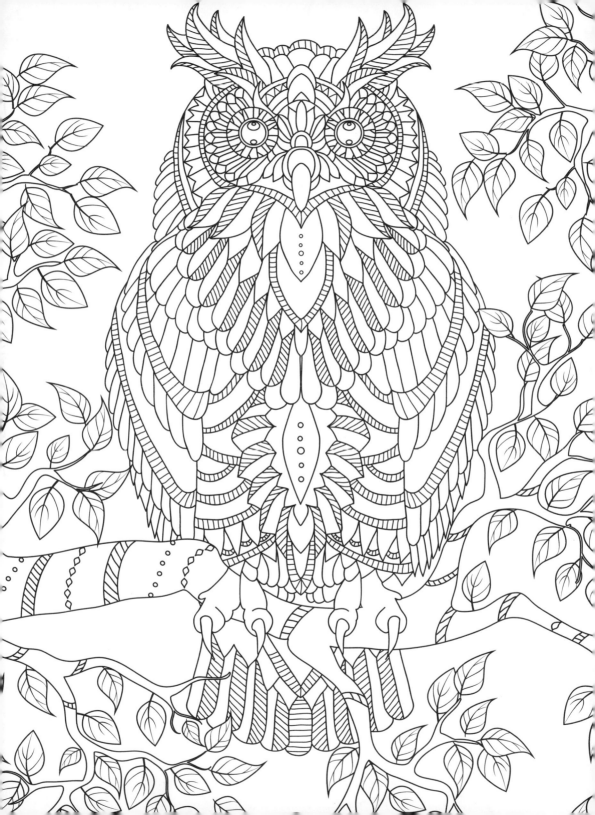

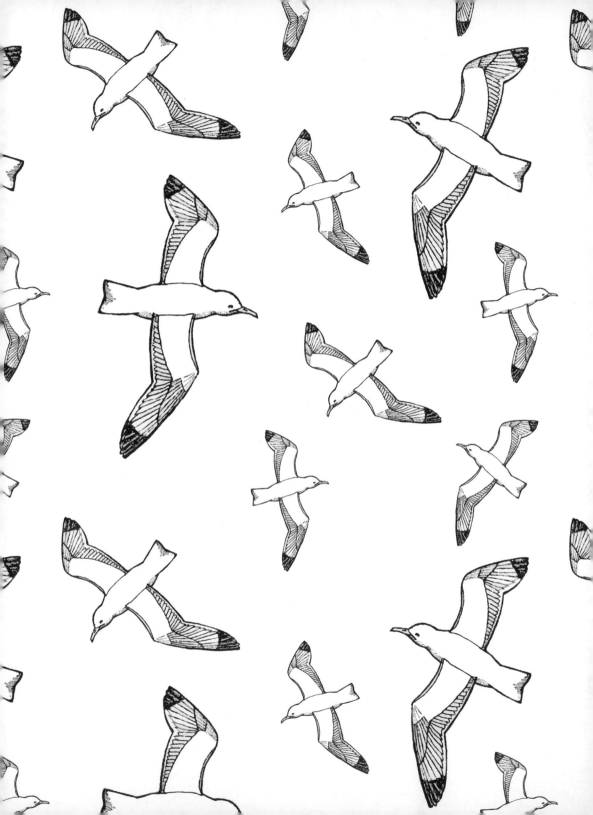

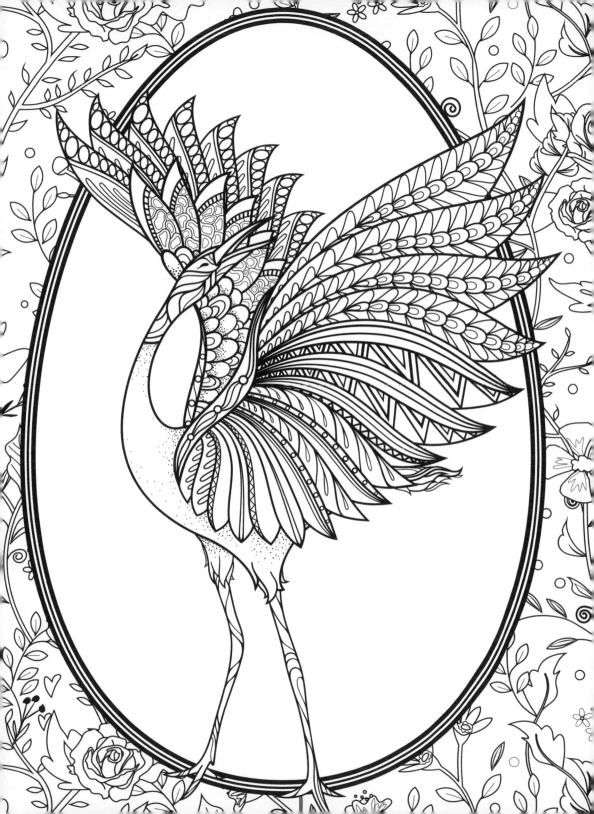

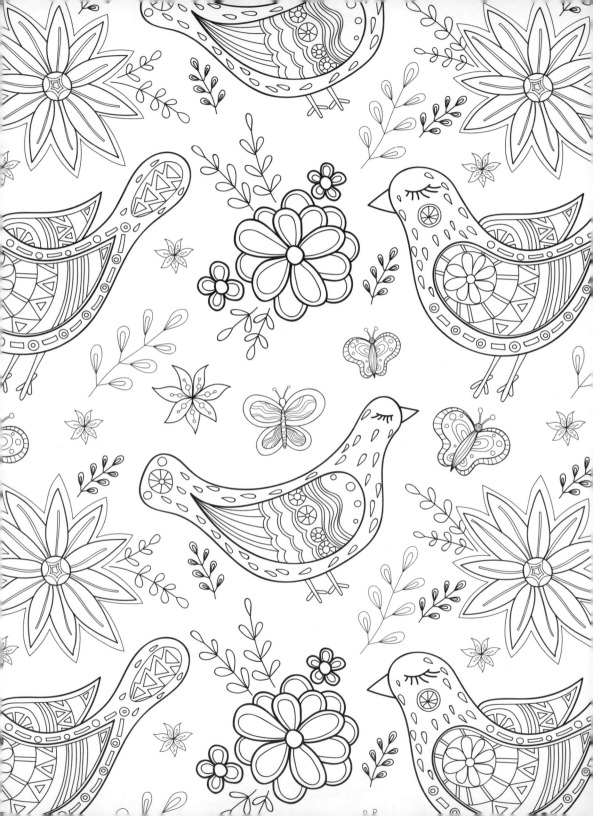

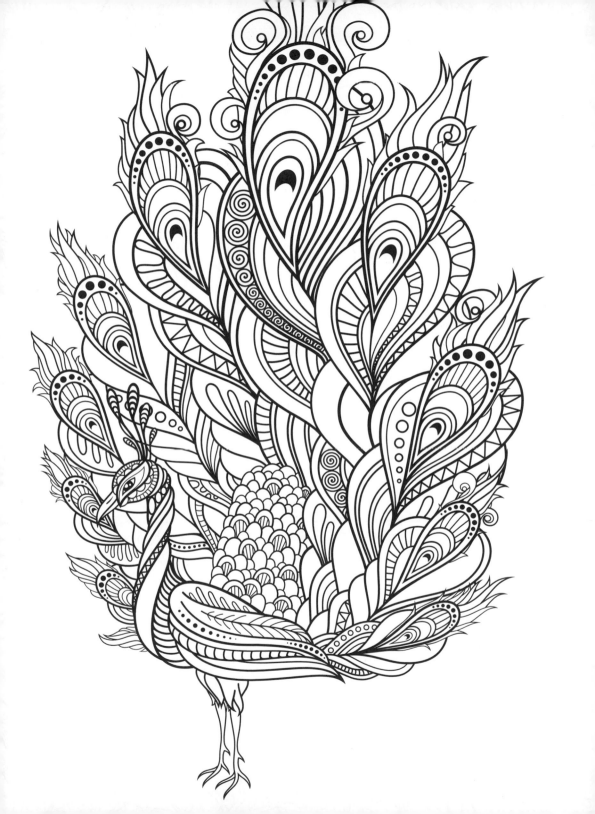

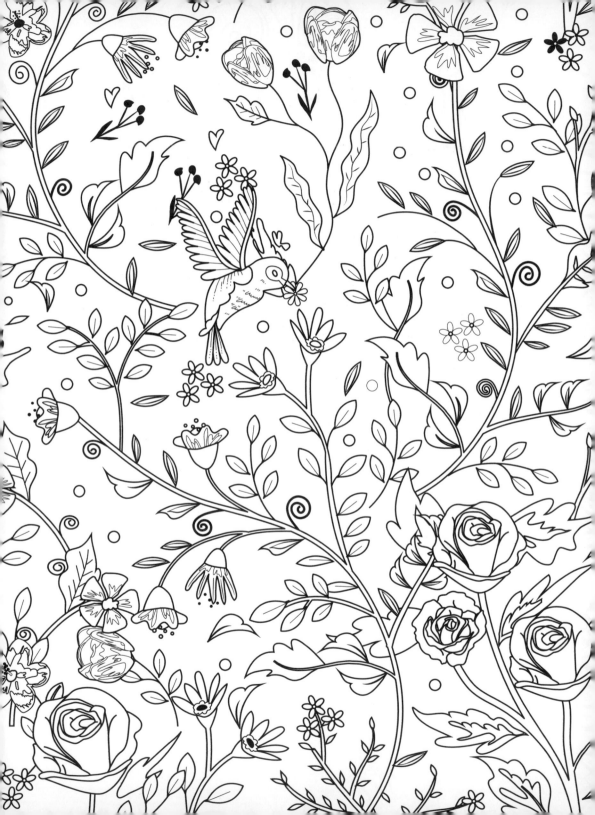

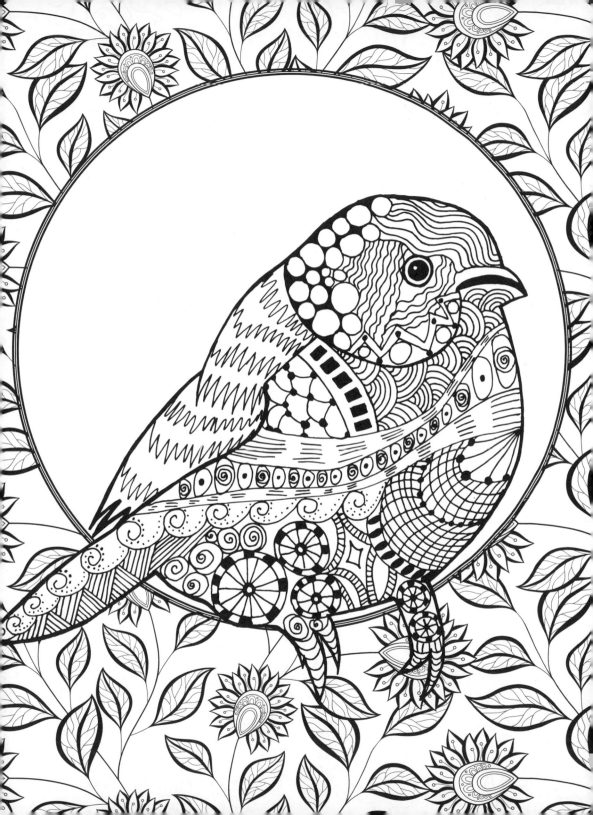

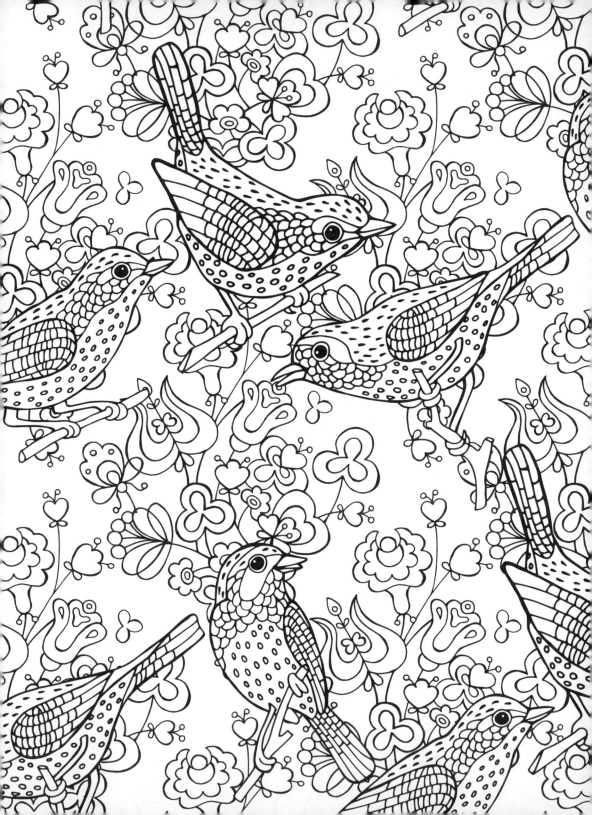

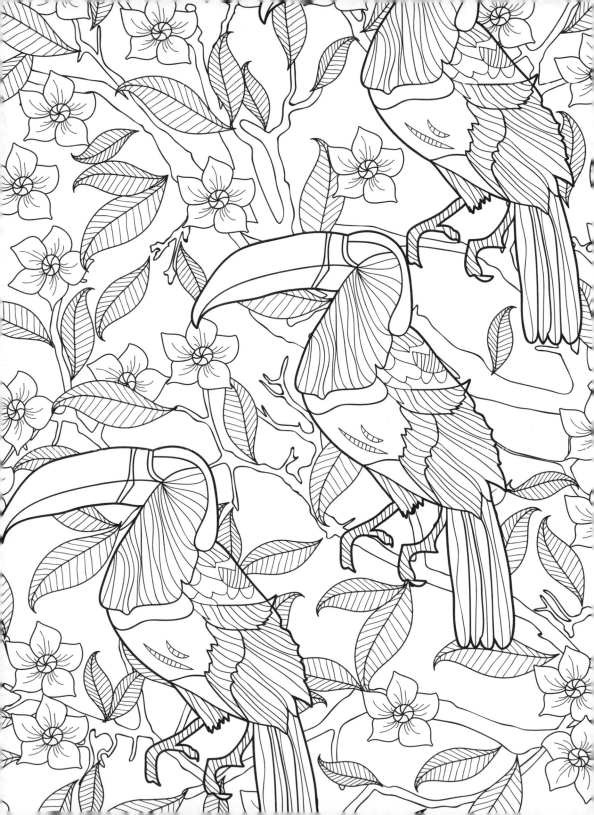

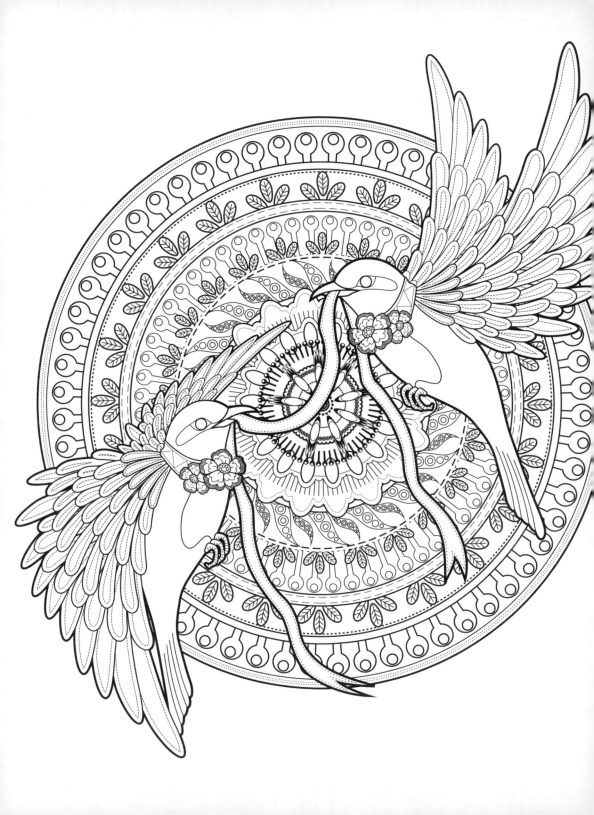

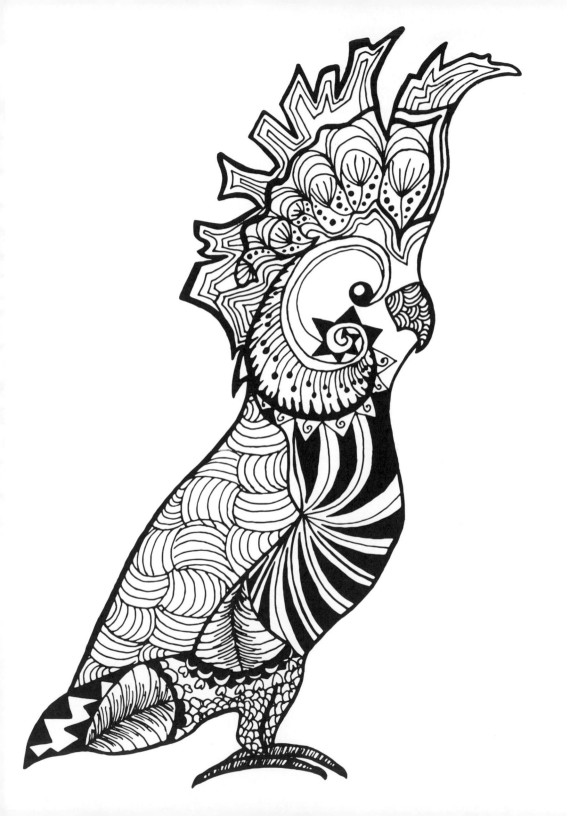

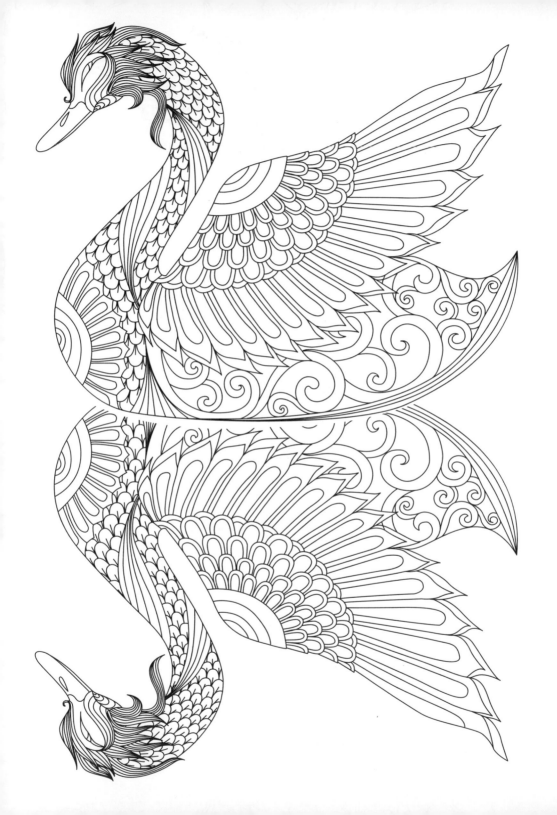

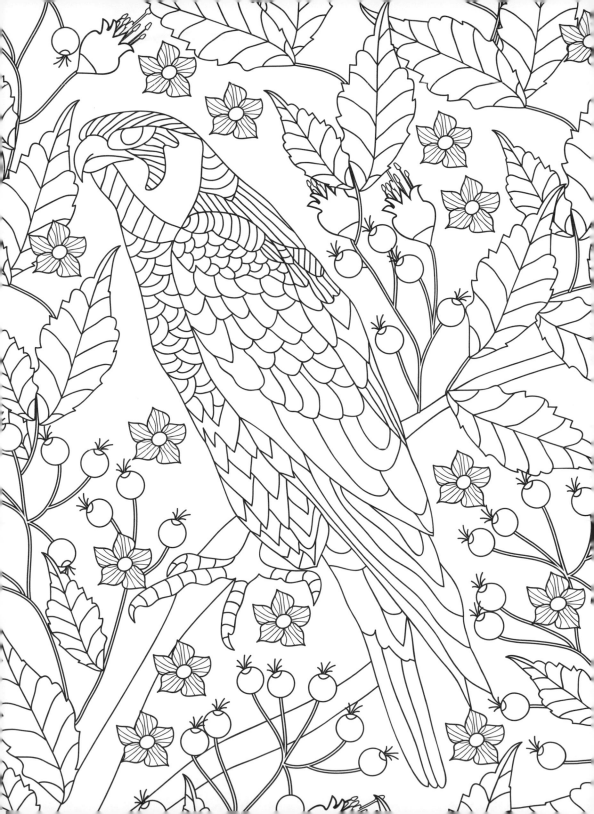

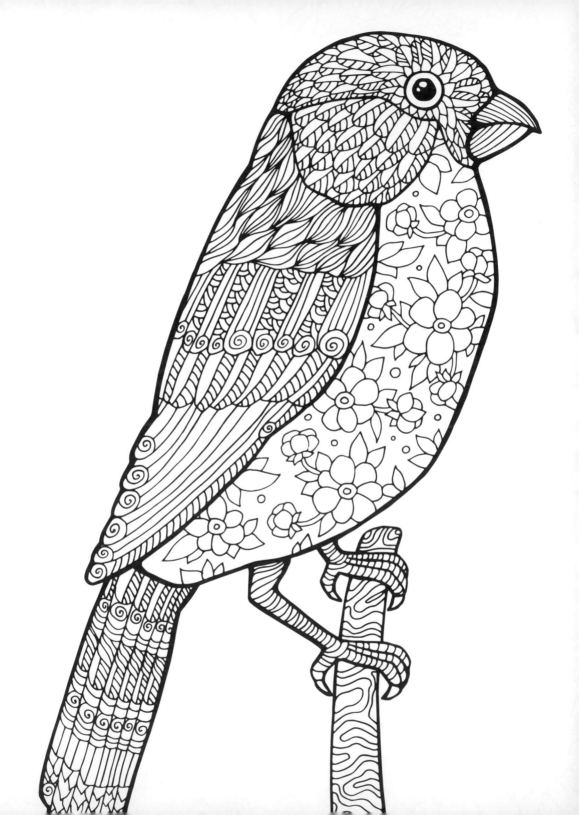

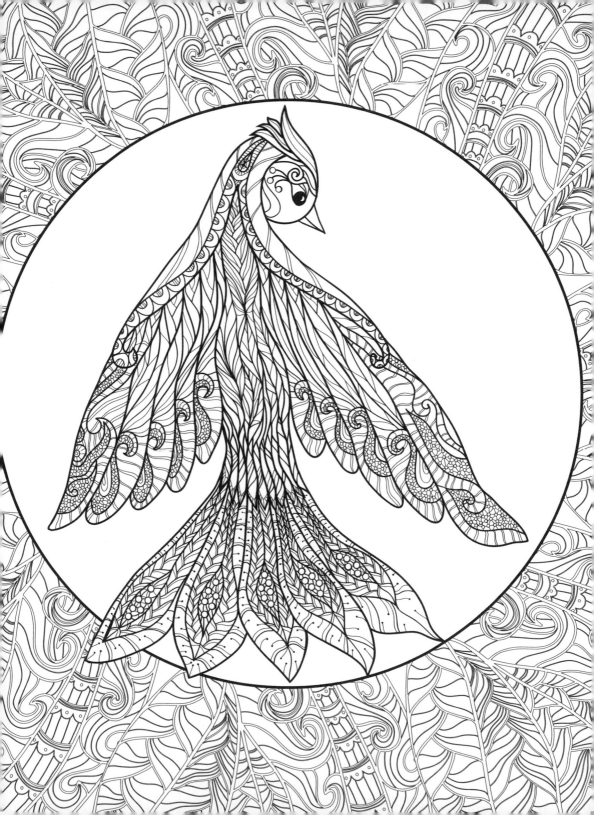

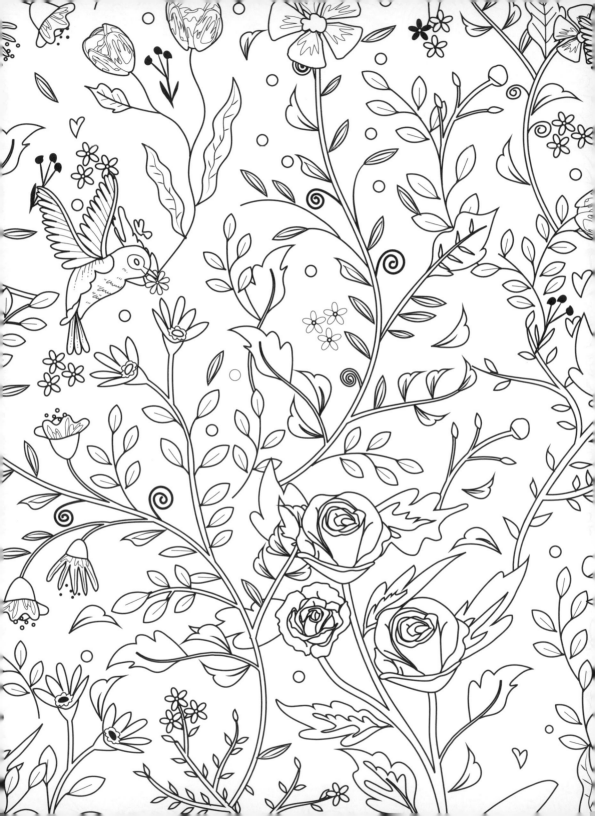

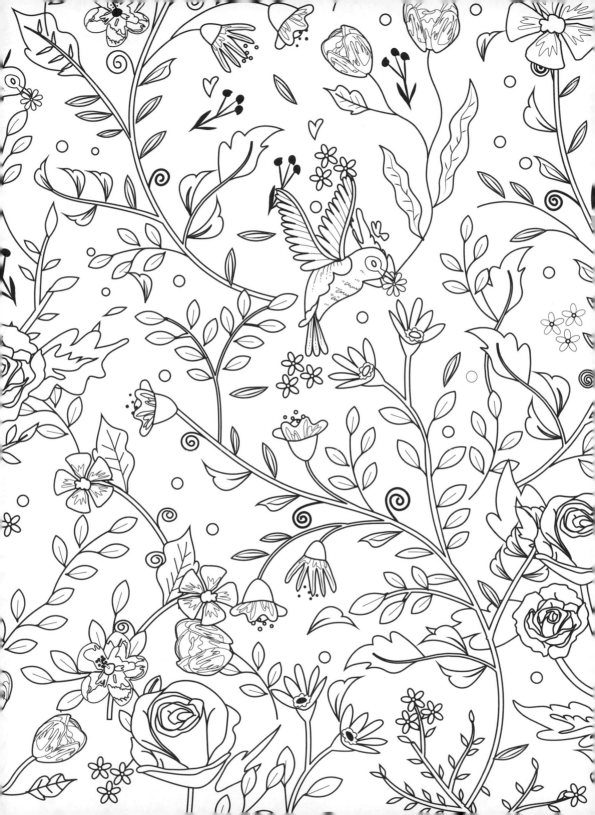

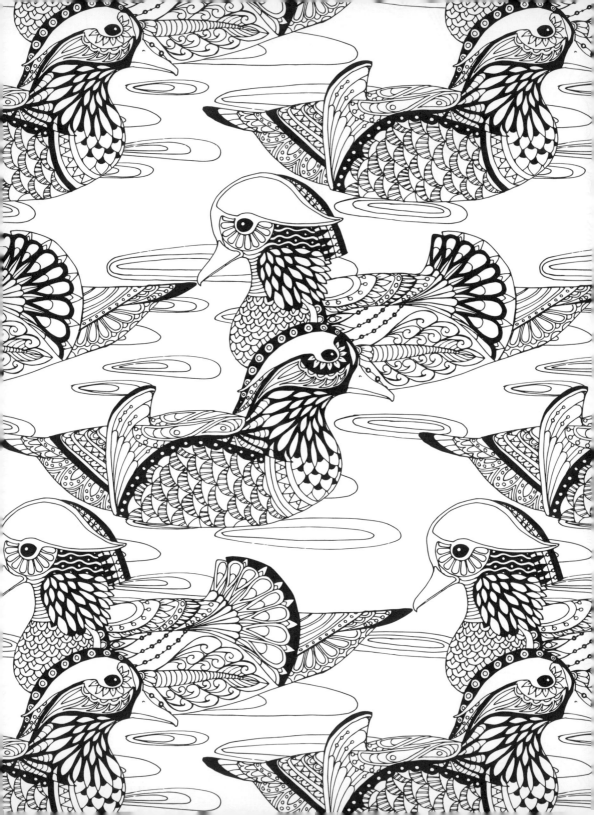

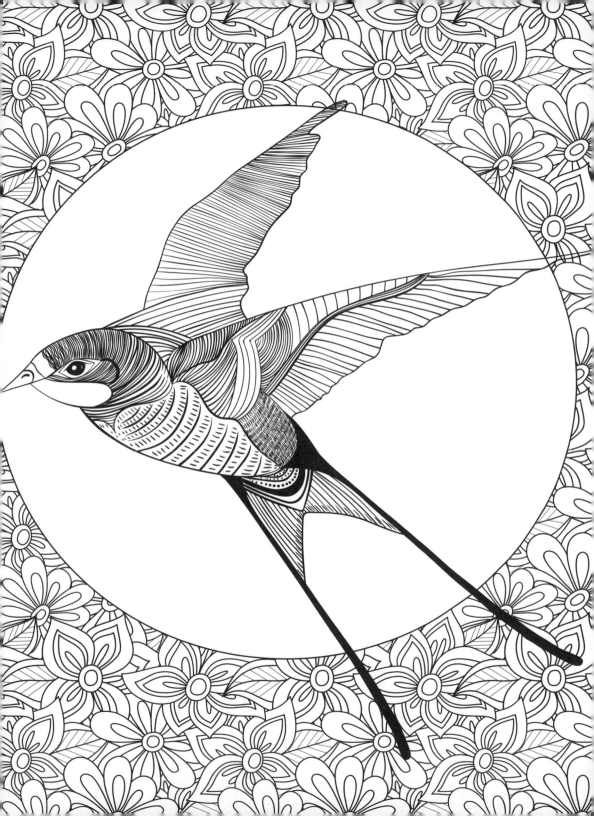

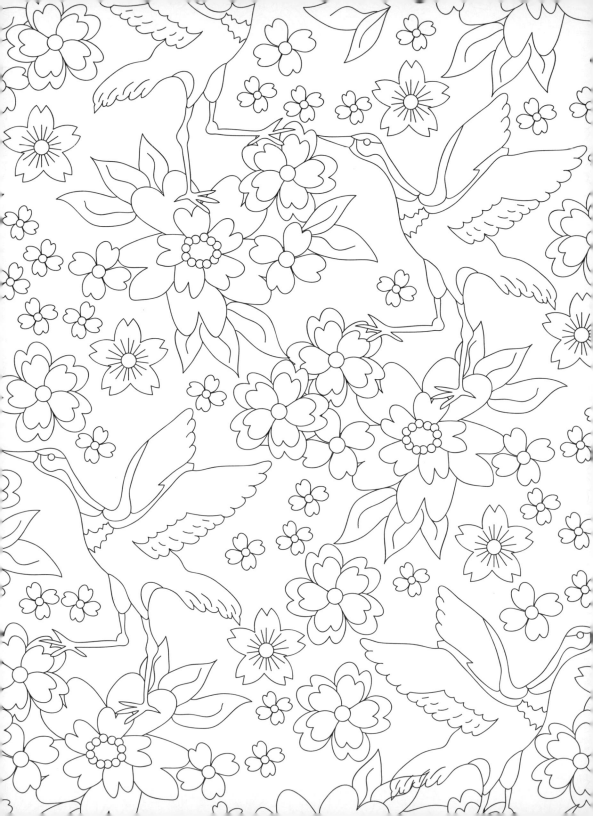

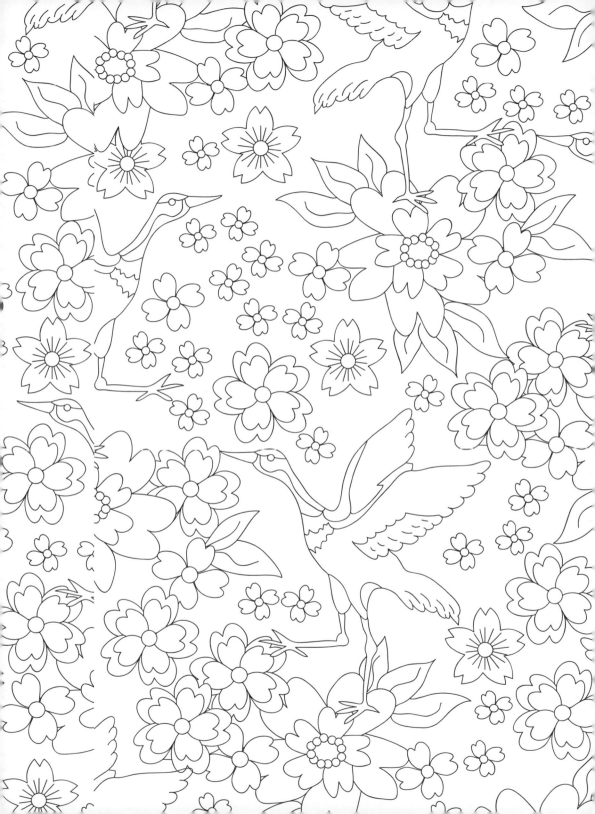

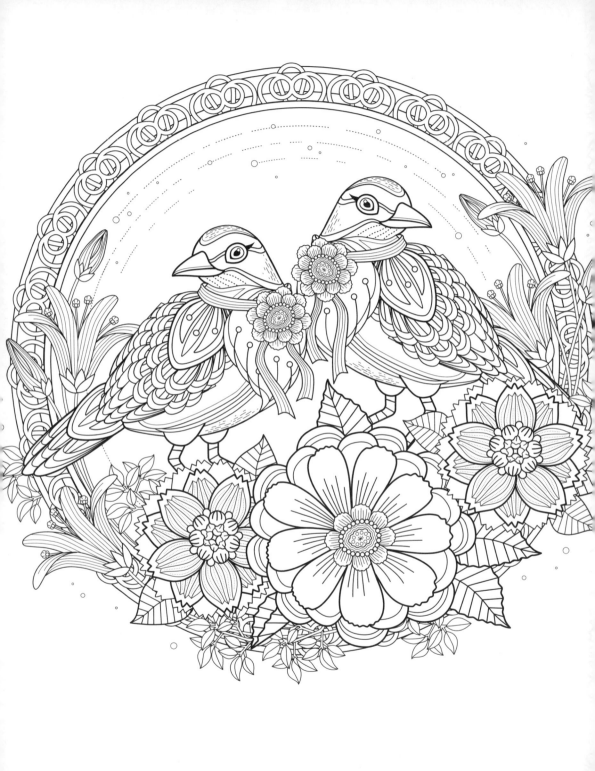

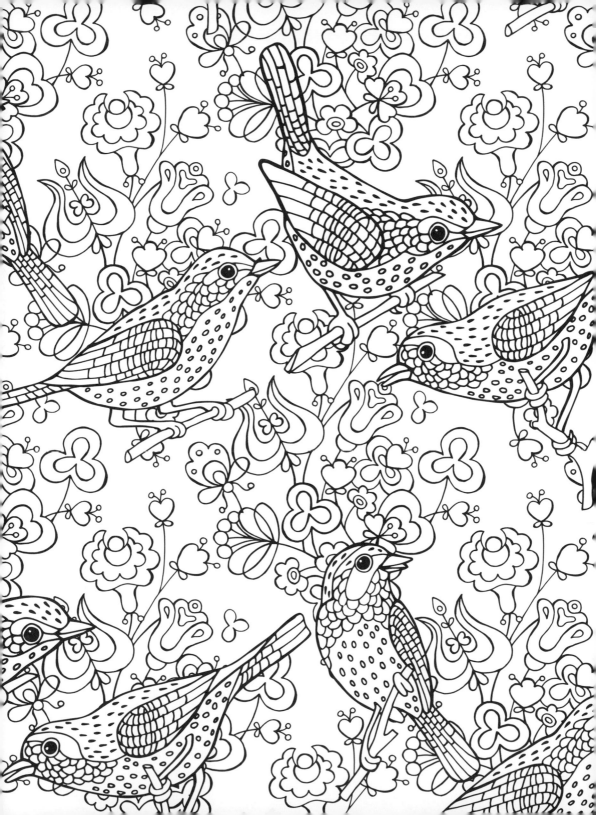

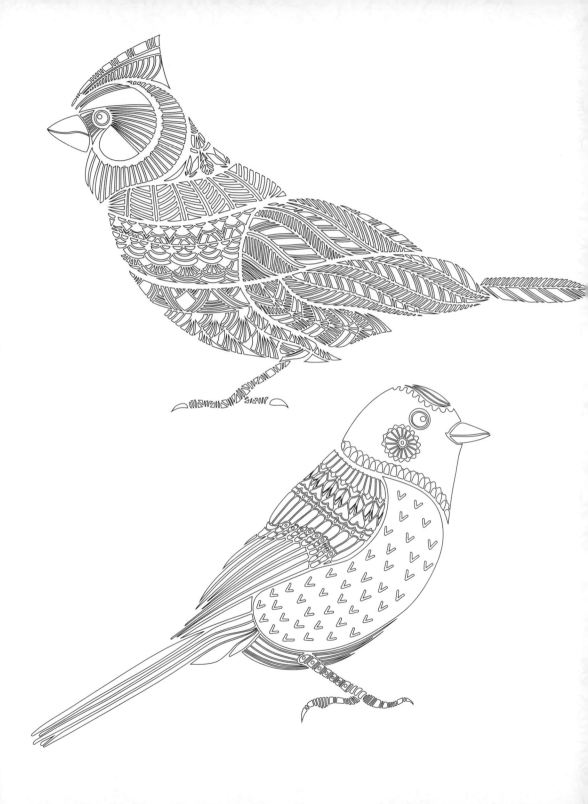

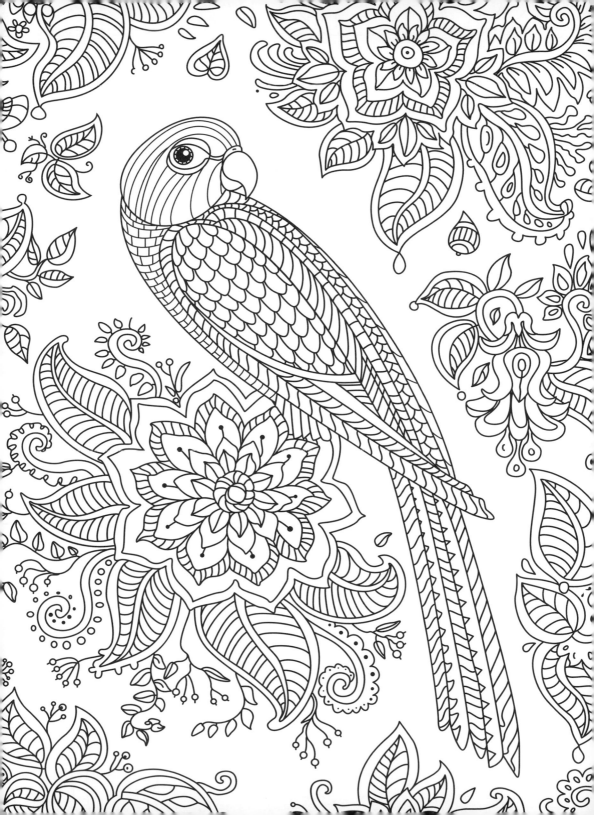

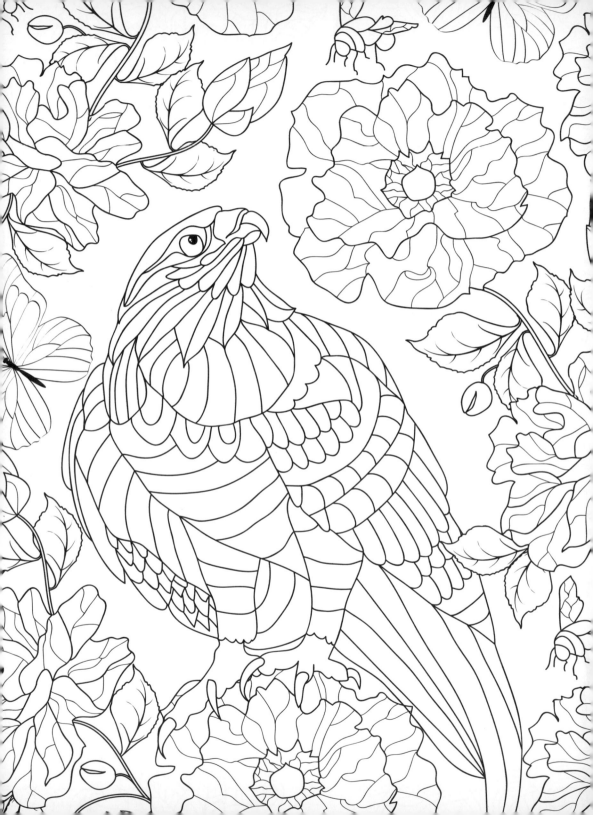

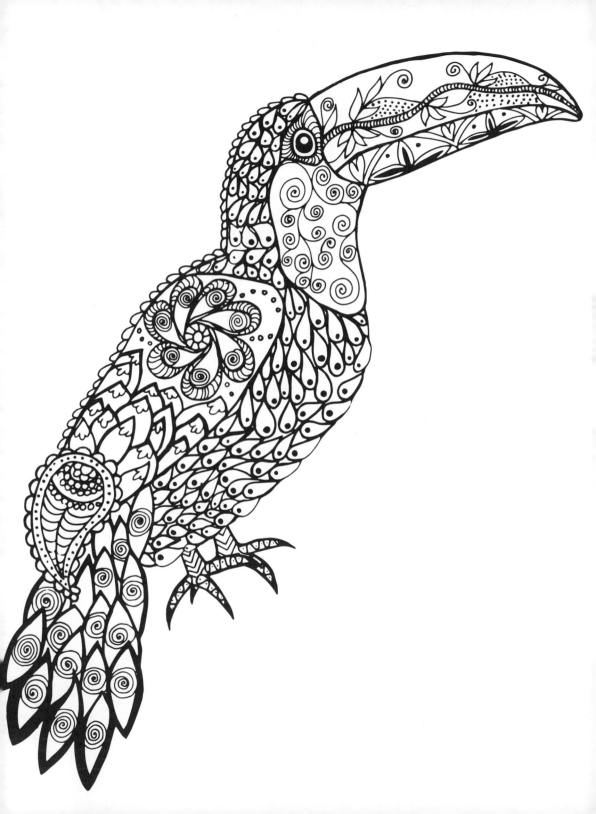

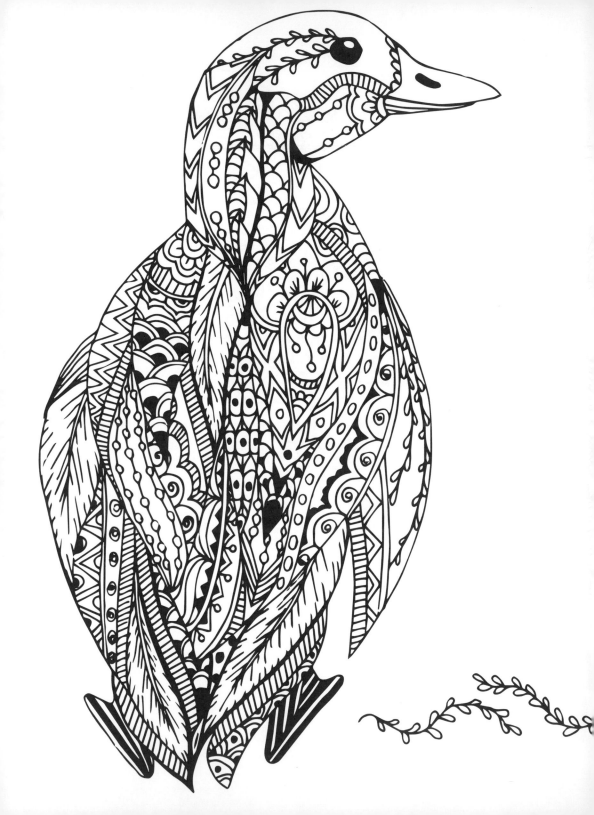

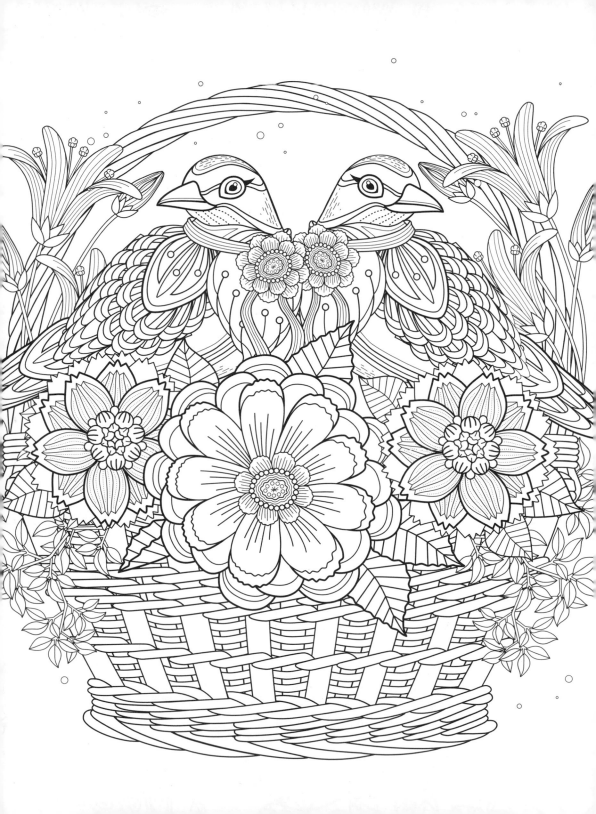

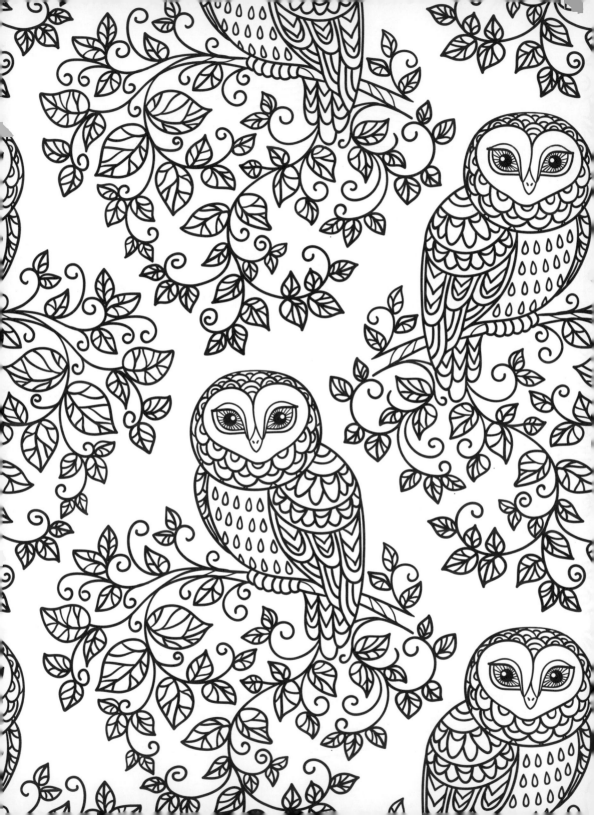

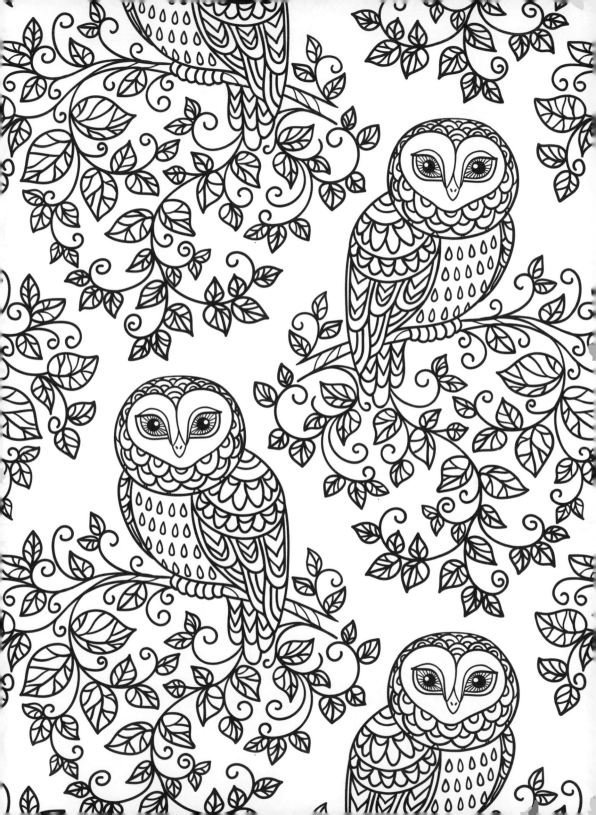

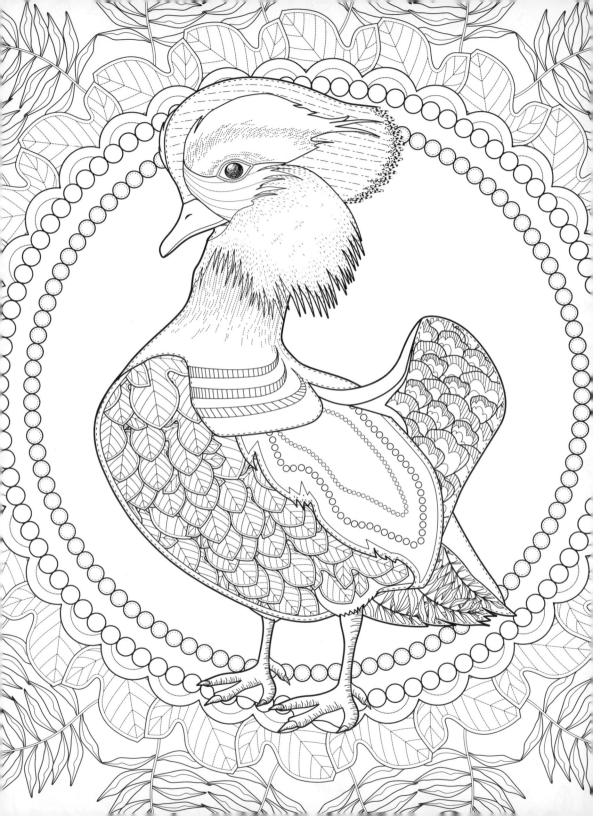

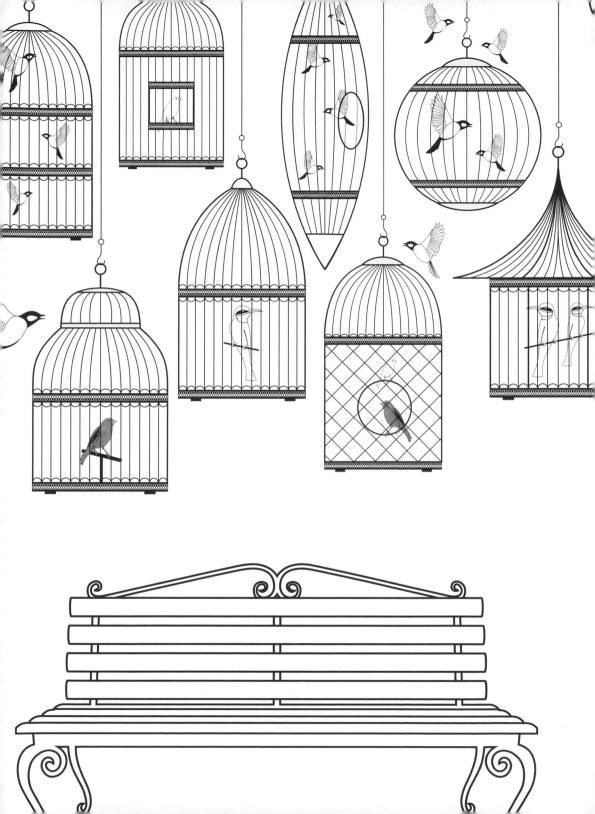

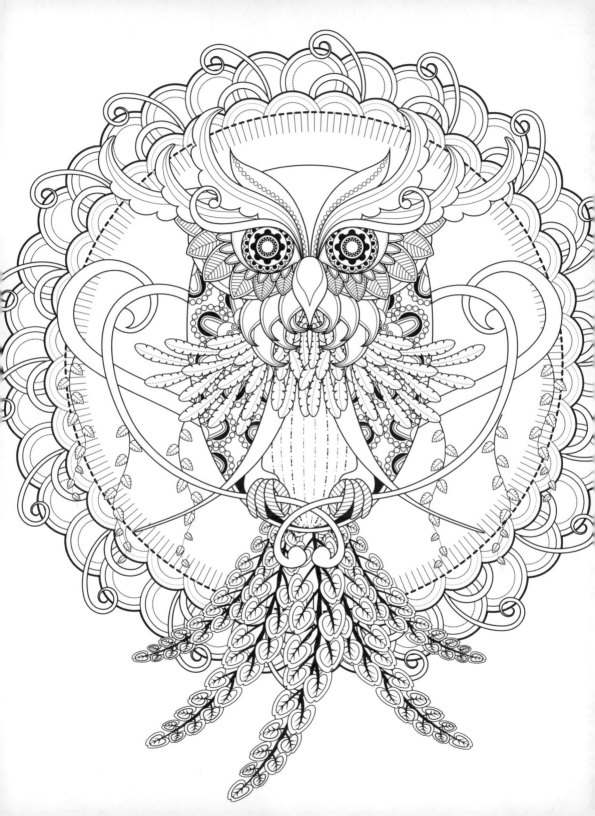

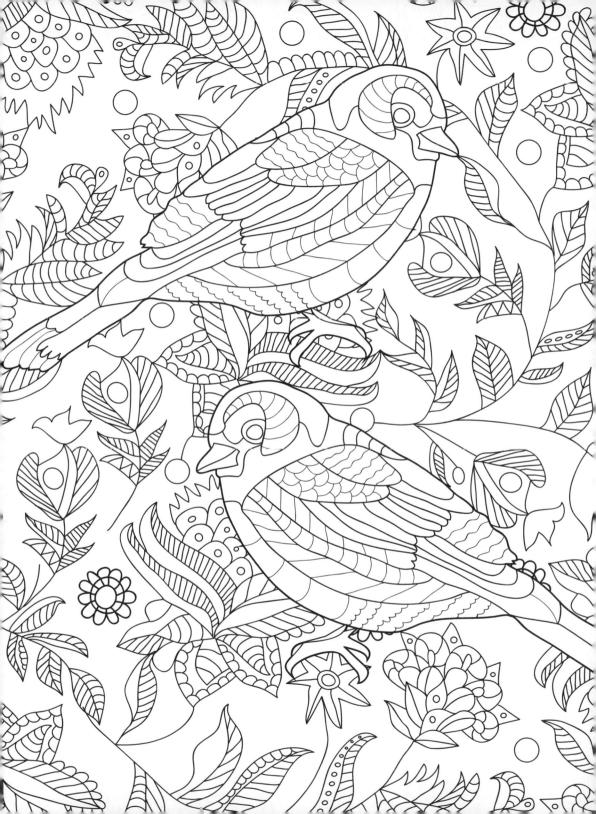

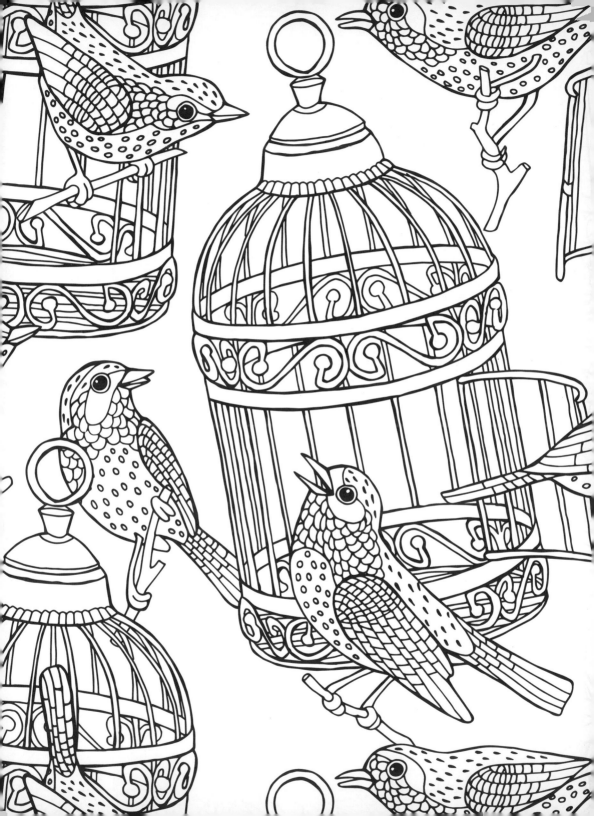

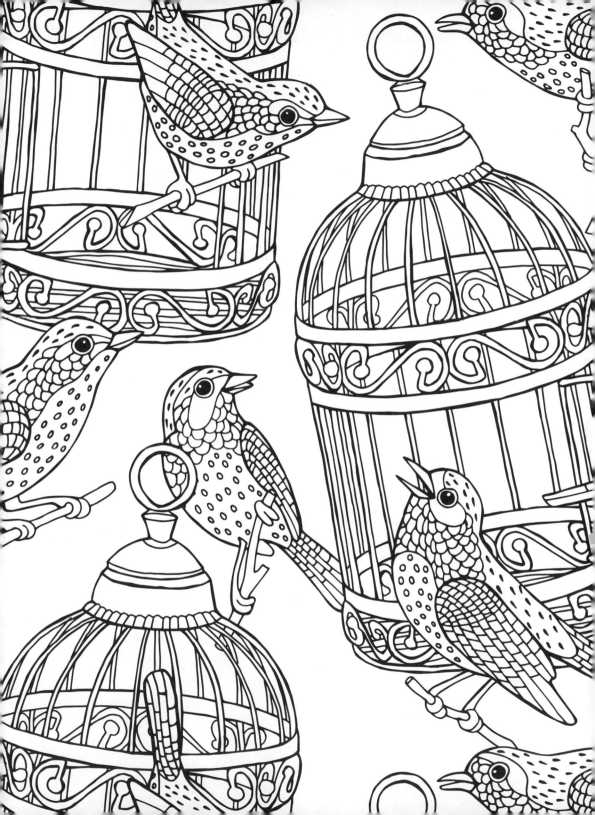

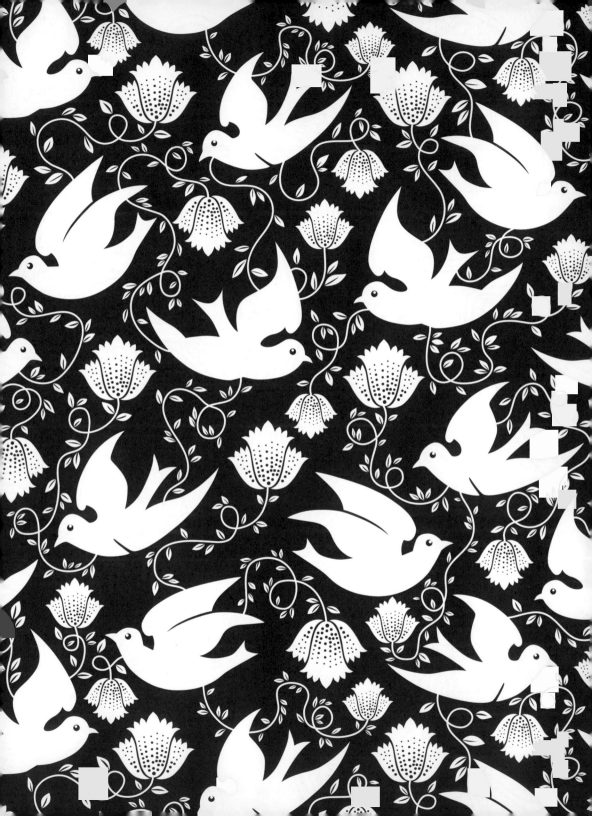

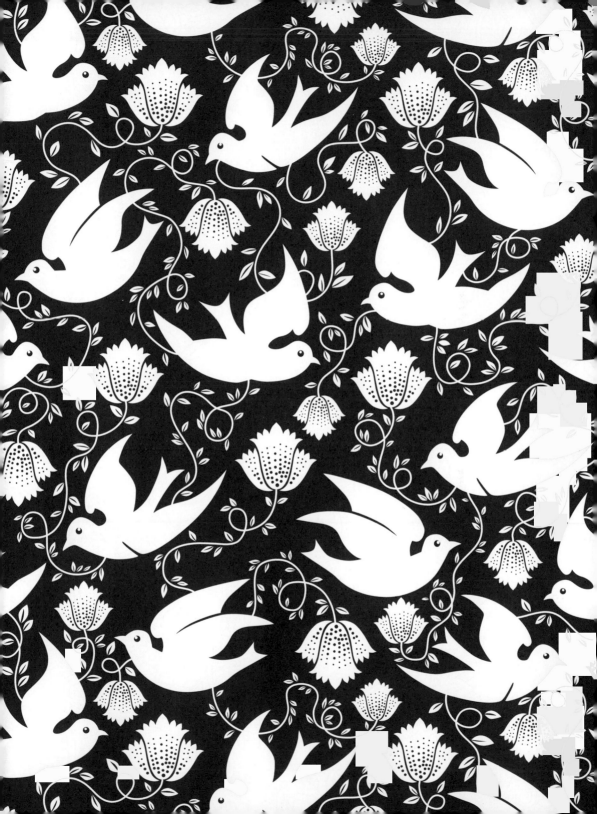

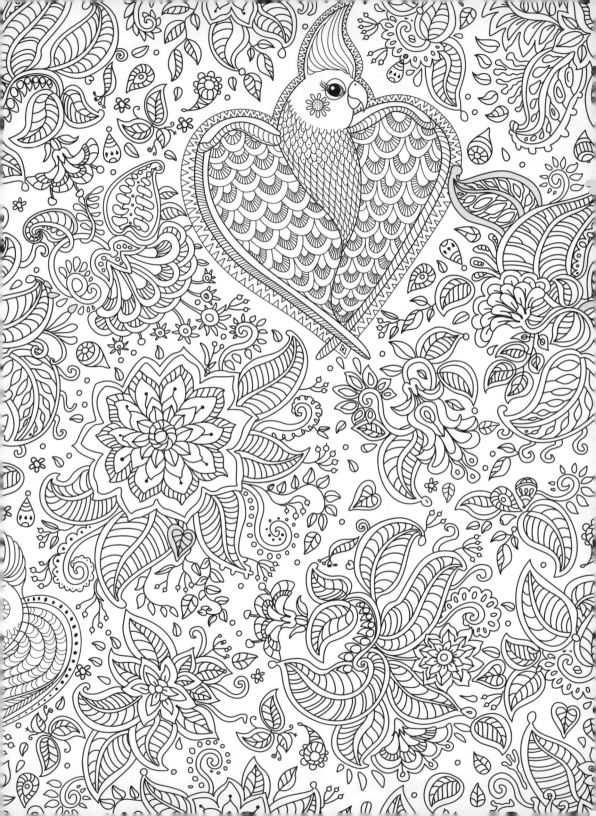

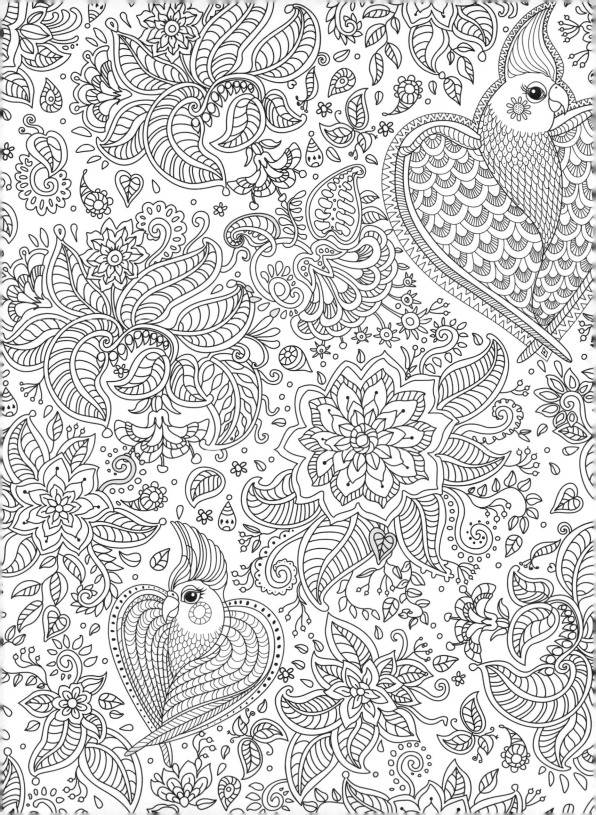

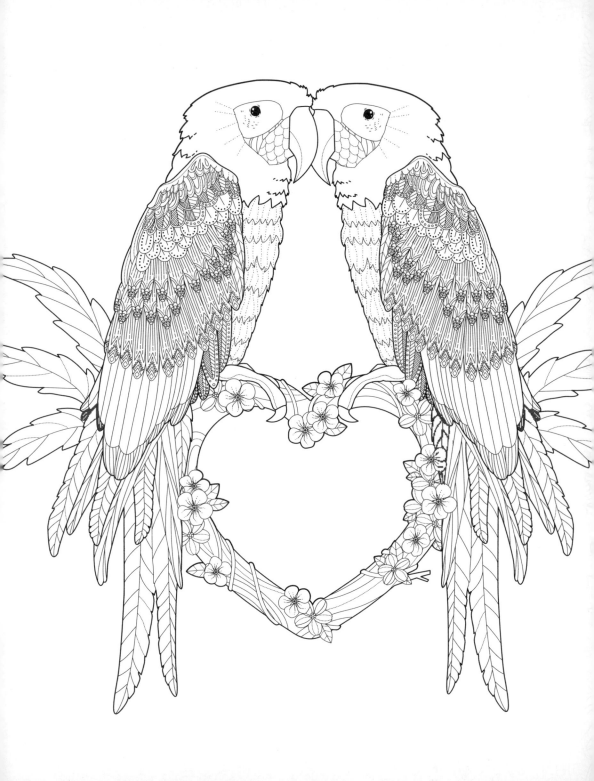

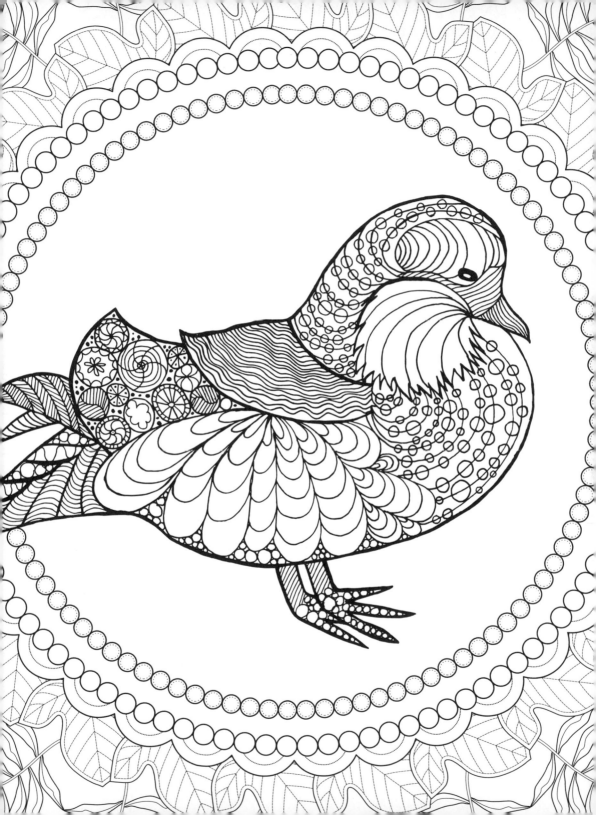

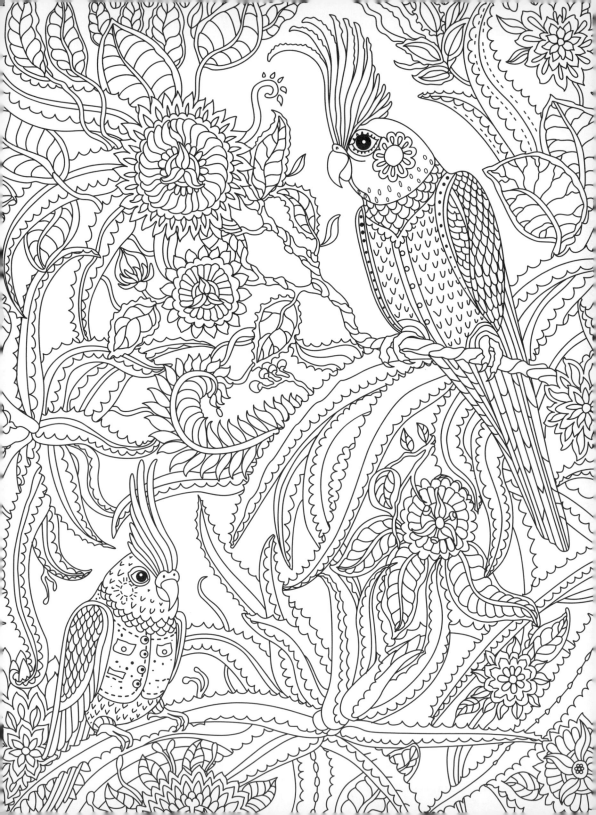

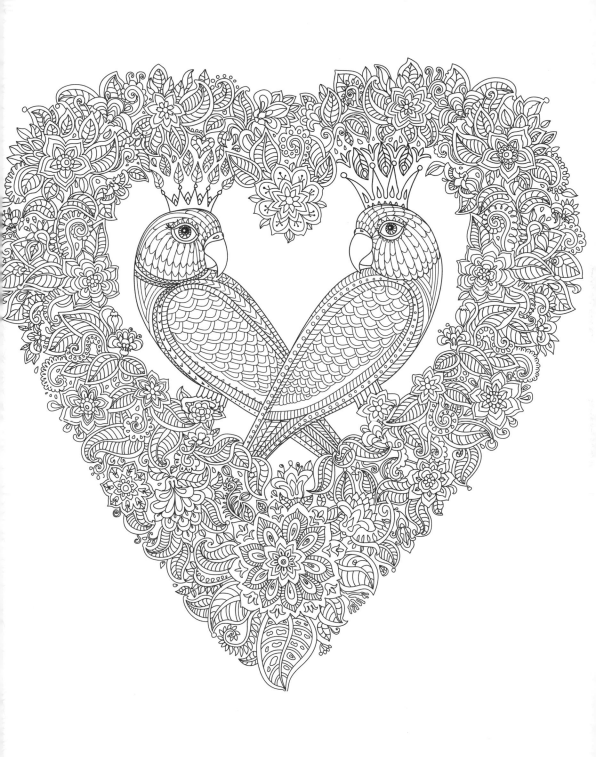

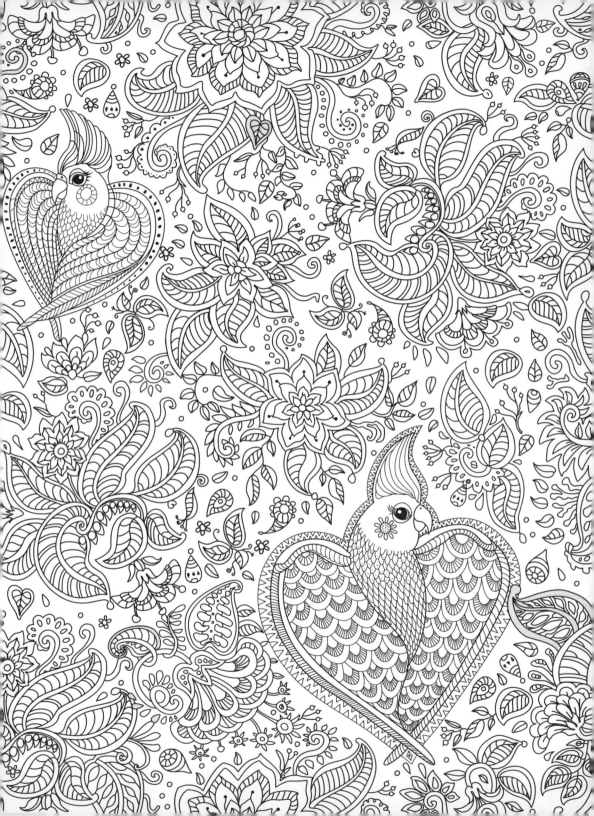

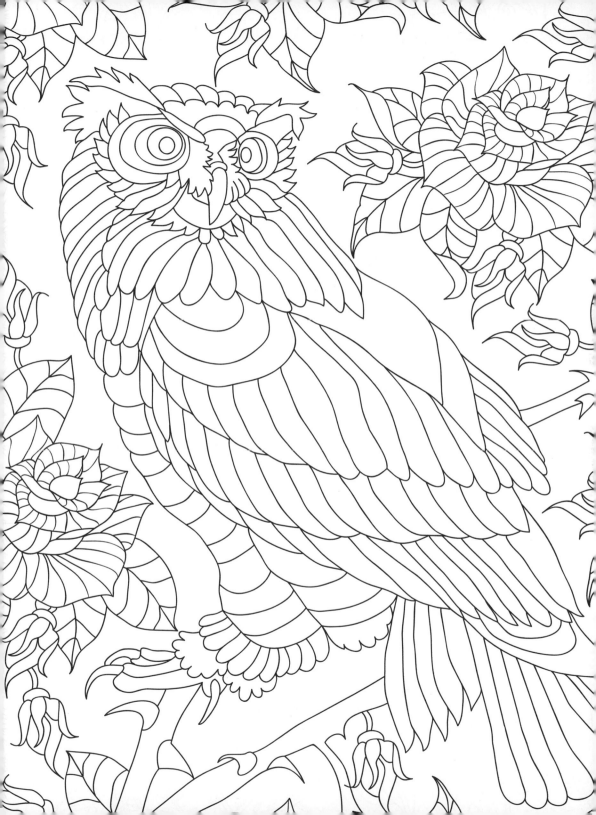

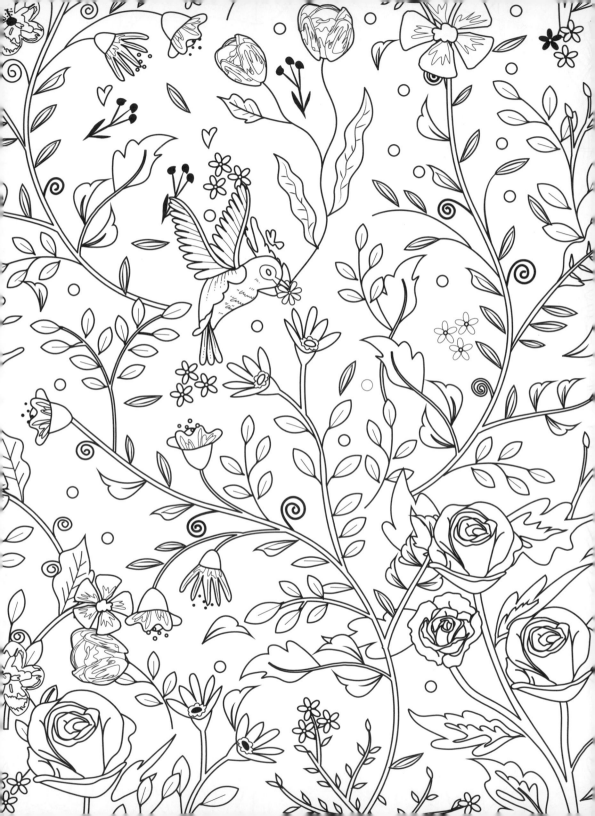

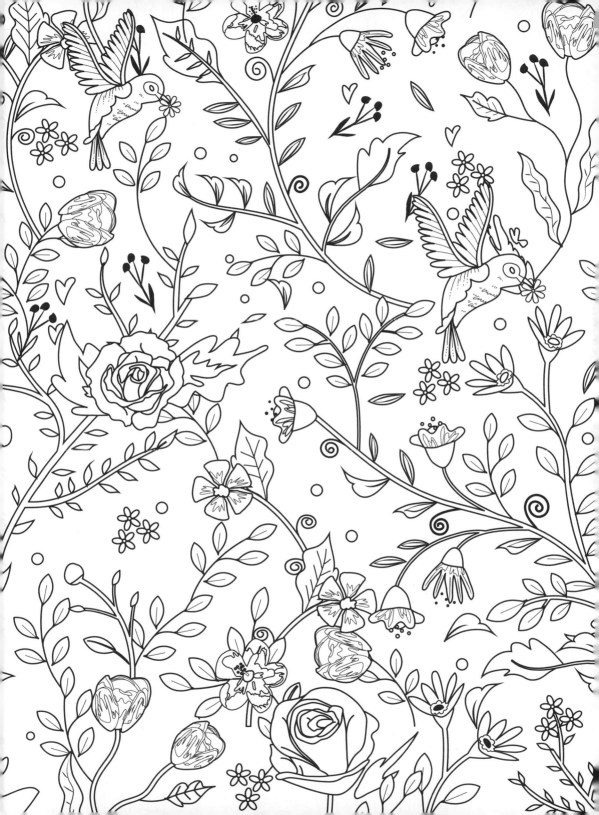

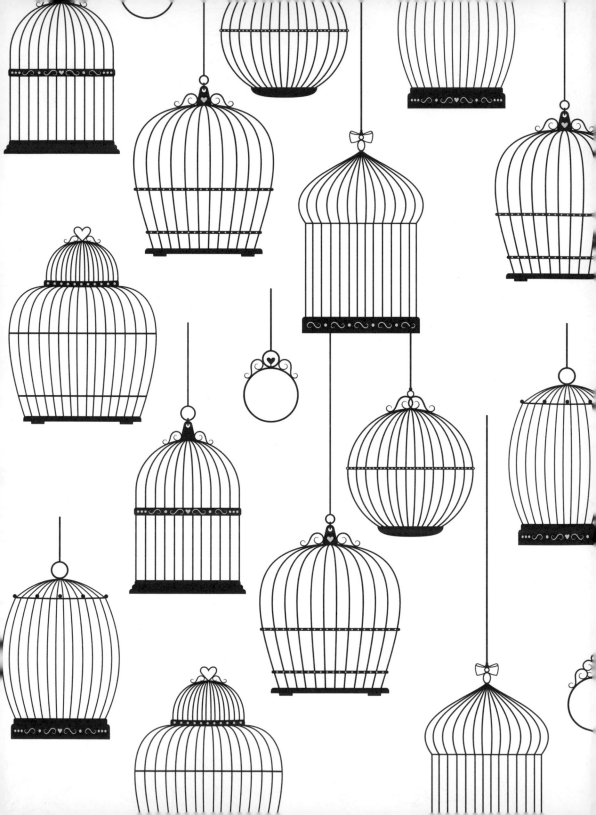

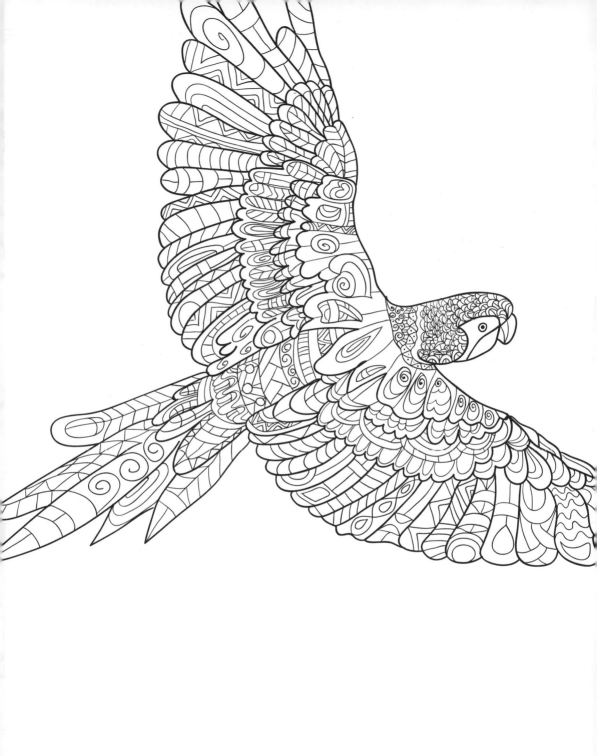

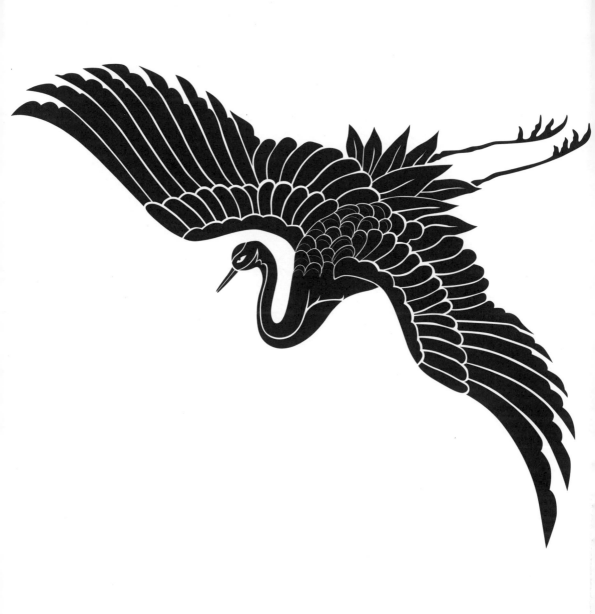